JOHN ARMSTRONG

1893–1973

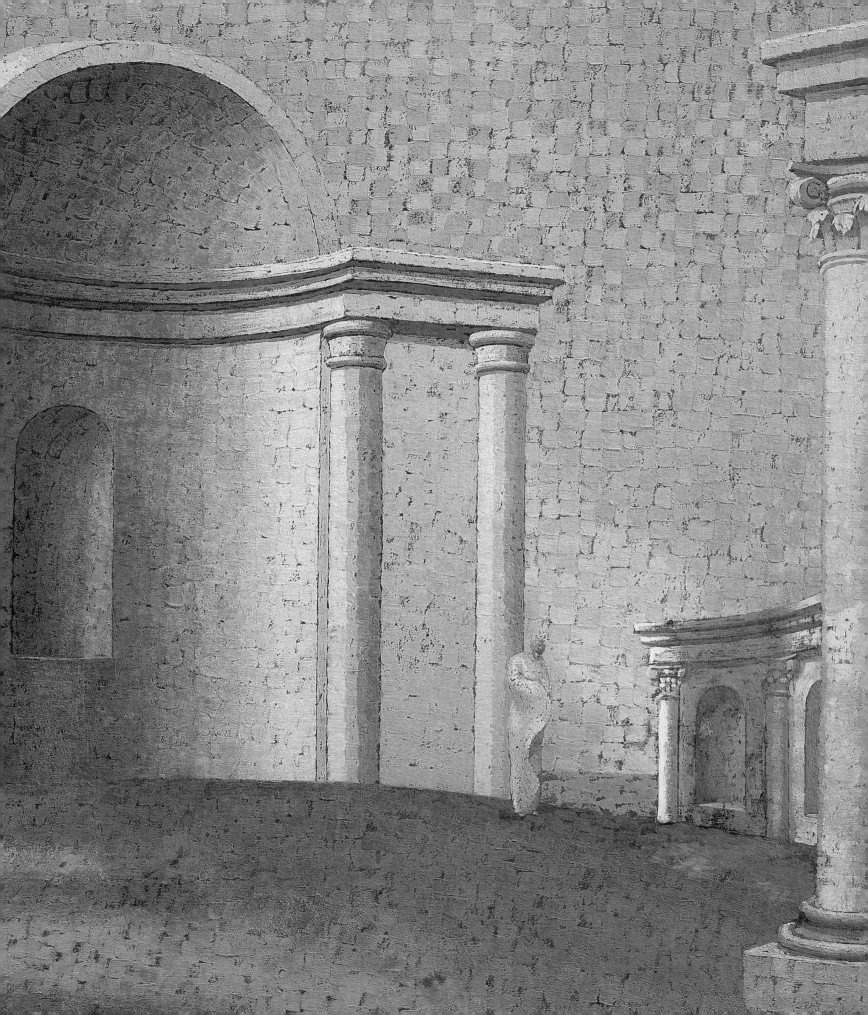

JOHN ARMSTRONG

PAINTINGS 1938-1958

AN ENCHANTED DISTANCE

PIANO NOBILE

NOBILE

PIANO NOBILE | ROBERT TRAVERS WORKS OF ART LTD
129 Portland Road | London W11 4LW | T +44 (0)20 7229 1099
info@piano-nobile.com | piano-nobile.com

JOHN ARMSTRONG 1938

PIANO
——————
N O B I L E

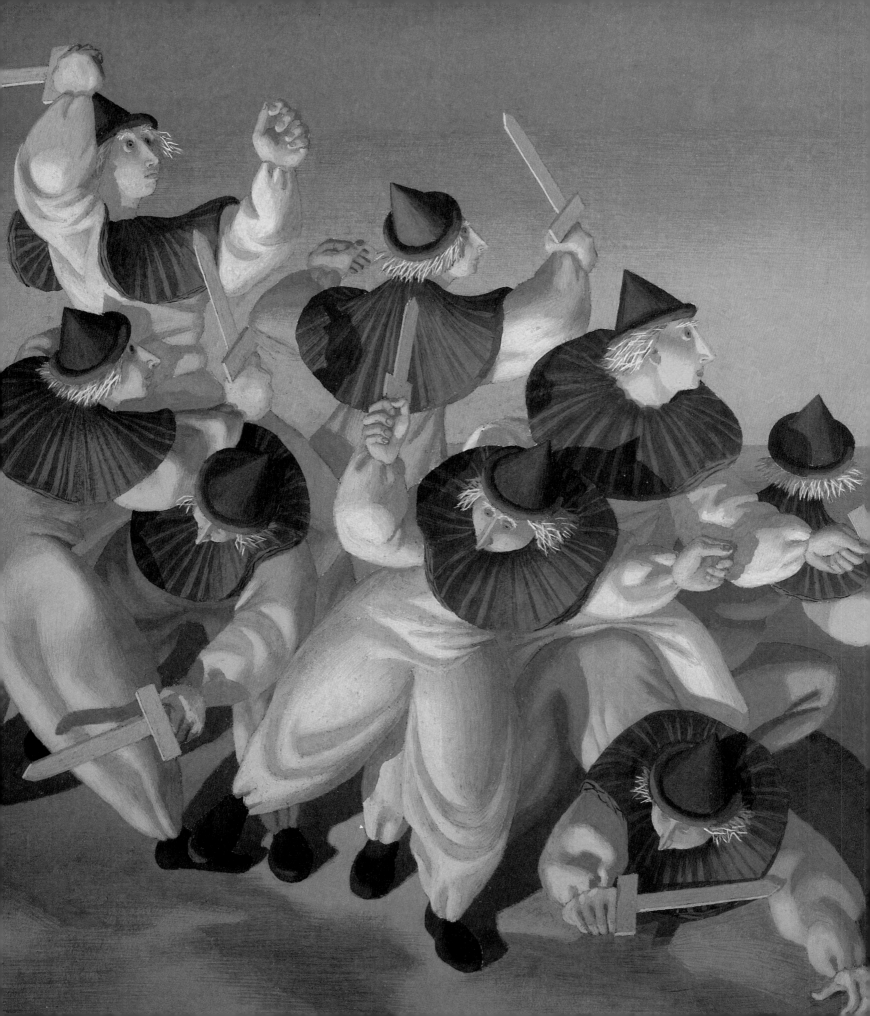

As the curator of the 2014 exhibition '*Conscience and Conflict: British Artists and the Spanish Civil War*' at Pallant House Gallery I faced the difficult conundrum of what could possibly be hung alongside Pablo Picasso's iconic painting of the *Weeping Woman*. A group of understated tempera paintings of ruined buildings by John Armstrong might have seemed an unlikely choice to juxtapose with the energy of this visceral image. But in their chilling quietness and unsettling clarity Armstrong's paintings provided a powerful moment within the exhibition. Numerous art critics and visitors were to comment on the restrained, but arresting quality of his works.

The paintings included in the present exhibition date from 1938 to 1958. This date not only represents a potent moment in the history of European politics, but it also marks Armstrong's maturity as an artist. During the late 1920s and early 1930s Armstrong had been the creator of classicising, often whimsical, paintings that represented an English response to the 'return to order' of Cocteau, Picasso and De Chirico. But from the late 1930s Armstrong's work took on a weight that reflected his turbulent age without ever making overtly political statements. Working in egg tempera, a medium more associated with the Italian Renaissance than the post-war age, Armstrong was to create seemingly timeless paintings.

Armstrong's paintings of the 1940s and 50s have a distinctive atmosphere that sets him apart from many of his contemporaries. The beautifully rendered, tessellated surfaces play with our perception of depth and perspective. Even at their most decorative Armstrong's paintings have a quality of strangeness, which, although he was not a conventional 'Surrealist', raises metaphysical questions, and suggests a reality beyond the immediately visible.

Simon Martin
Artistic Director, Pallant House Gallery

Cat. 13, *The Battle of Nothing*, 1949 (detail)

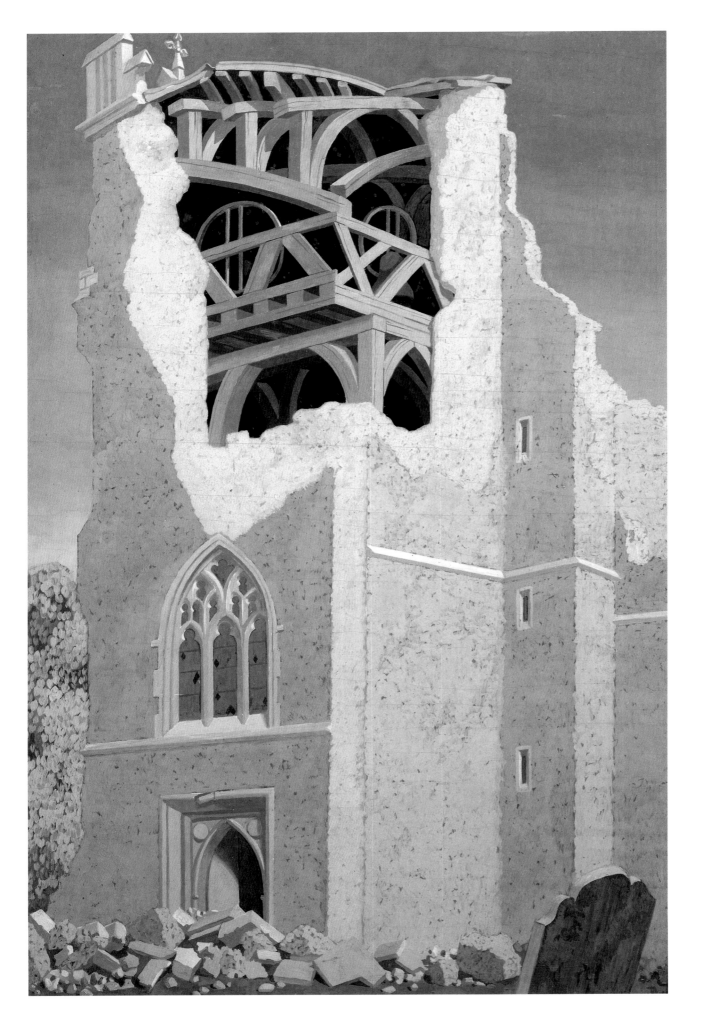

In December 1938, the third solo exhibition of paintings by John Armstrong (1893-1973) opened at Alex Reid and Lefevre Gallery on King Street, St James's in London. To the delight of the gossip columns, the Hollywood film stars Charles Laughton and Elsa Lanchester threw a party to celebrate the opening, at which, according to the *Yorkshire Post*, "artists mingled with stars and magnates of the film world".[1] *Sketch* magazine complimented Mrs Benita Armstrong as "a perfect Victorian in a pale grey, perfectly-fitting dress with a waterfall back" whilst the *Edinburgh Evening News* revelled in Armstrong's origins in London society as a co-founder with Elsa Lanchester of the infamous London cabaret club, The Cave of Harmony.[2] The *News Chronicle* reminded its readers of Armstrong's glamorous previous incarnation as the set and costume designer for films by legendary producer and director Alexander Korda including *Henry VIII* and *The Scarlet Pimpernel*.[3] Alongside society column inches, Armstrong's show gleaned serious and sustained attention from critics across Britain, full of admiration for the surreal, dream-like quality of Armstrong's paintings, "a world dreaming itself into decay and dilapidation" concurred the *Manchester Guardian*.[4] Eric Newton in the *Sunday Times* wrote of an artist "obsessed by the oddity and loneliness of decay" whilst *The Scotsman* compared his works to an "Eliotesque 'Waste Land'".[5]

1938 was a significant year for John Armstrong and one of precipitous change. The resounding success of his Lefevre show was confirmed by the Tate's first purchase of one of the exhibited paintings, *Dreaming Head* [fig. 3]. His personal life, however, was in flux with the breakdown of his first marriage to Benita precipitating a move to Tilty in Essex. The political situation in Europe was becoming increasingly fraught: the Spanish Civil War dominated Armstrong's exhibition with such overtly political works as *Pro Patria*, 1938, [fig. 2] and *Encounter in the Plain*, c. 1938, [cat. 2] making manifest the devastation of General Franco's aerial bombardment of the civilian population of Spain. Just three months before the opening of Armstrong's exhibition, Picasso's *Guernica* went on display at the Whitechapel Art Gallery in London and, as with so many of his contemporaries, had a profound impact upon Armstrong.

The Lefevre show signalled for Armstrong the beginning of two decades of immense productivity, creativity and innovation with solo exhibitions at Lefevre in 1938, 1945, 1947 and 1951, and at Leicester Galleries in 1957 alongside various group shows. Whilst constantly evolving and experimenting with his tempera and oil painting techniques, Armstrong consistently produced visionary, surreal works of emotional and political insight. Romantic yet challenging, Armstrong's works speak of the universal through his own individual language. John Armstrong was a deeply independent artist, rejecting the confinement of artistic groups, yet he was at the heart of inter-war and post-war British art, also serving

Fig. 1, *Coggeshall Church, Essex*, 1940; Tate

as an Official War Artist on the Home Front during World War II, producing such works as *Coggeshall Church, Essex*, 1940; Tate [fig. 1]. His work engages with European and International artistic movements, whilst addressing the political legacy of World War II, the humanitarian horrors of the Holocaust and Hiroshima, and the new threat of the Cold War and nuclear apocalypse.

In the introduction to the 1938 exhibition catalogue, T. W. Earp, art critic at the *Daily Telegraph*, writes of what Armstrong's paintings ask of the viewer: "they invite, as mental imagery, the association of the spectator in the idea".[6] The subtle disquiet of Armstrong's art lies in the suggestion of malformed objects, contorted faces, foreboding landscapes, uncanny juxtapositions, unsettling scale distortion, or unnaturally heightened detail. As Earp concludes, "The actual provides a half-way clue to this work: at its end opens the enchanted distance".[7]

Fig. 2, *Pro Patria*, 1938; Imperial War Museum

John Armstrong was born in Hastings, Sussex in 1893, the third of six children to a strictly religious and highly arudite parson and his wife. When Armstrong was two years old, the family moved for his father to take up the parish of West Dean, Chichester. Armstrong studied at St Paul's School, London followed by a brief period at the St John's Wood School of Art. His studies were interrupted by World War I, and he enlisted to serve in the Royal Field Artillery. He survived the war and upon the conclusion of hostilities, Armstrong returned for a short period to St John's Wood School of Art, before taking up a studio in Fitzrovia as a professional artist.

Armstrong came to prominence as a leading figure of the British avant-garde through his involvement with Unit One, the short-lived but highly influential group of artists, sculptors and architects that included Edward Wadsworth, John Bigge, Edward Burra, Ben Nicholson, Henry Moore, Barbara Hepworth, Wells Coates and Colin Lucas. Brought together under the auspices of Paul Nash and critic Herbert Read, the aim of the group was to seek, through diverse ways, "the meaning of 'the contemporary spirit'" as Nash wrote in the catalogue to the group's only exhibition in 1934 at the Mayor Gallery.[8] Within Unit One, Nash sought to unite two opposing artistic poles of abstract and figurative practices; this figurative element, although without the participation of John Armstrong, formed the core of the British component of the first Surrealist exhibition in London in 1936.

Armstrong never joined the Surrealists, probably due to his life-long Labour support and distaste for group-joining, but significant parallels abound between his practice and Surrealist strategies. As with so many of his contemporaries, including Nash and later Cecil Collins, the early influence of the English romantic tradition of William Blake, Aubrey Beardsley and the Pre-Raphaelites informed his lyrical, visionary imagery. In the catalogue to the 1936 Surrealist exhibition, Herbert Read argued that Surrealism was a continuation of "a principle of life, of creation, of liberation...the romantic spirit".[9]

The dream-like aesthetic of Armstrong's paintings originated with this romantic heritage, but the images themselves were derived from Armstrong's dreams. Following Sigmund Freud's revolutionary exploration of the subconscious and the dream as a manifestation of repressed memories, desires and wish-fulfilment in *The Interpretation of Dreams*, first published in 1900, the dream became integral to Surrealist poetry and art. In his statement for the Unit One catalogue, Armstrong wrote that his extraordinary imagery emerged from the "scattered fragments of my own mind, a desert with certain mirages on the horizon of broken columns and white horses and large women asleep".[10]

By 1938, Armstrong's explanation was more explicit: in an interview, wonderfully entitled 'Half-asleep Painter' with Ian Coster of the *Evening Standard*, he explained how "I paint usually with my mind half asleep not really knowing what I am trying to do", and several reviews mention the "semi-somnolent condition" in which such images appear.[11] Writing to a collector in 1953 Armstrong repeated the significance of dream imagery: "These things come to me as complete images, often when I am half asleep. I try to put them down as faithfully as I can. Afterwards I may have ideas about what they mean but I suppose only a conference of psychologists could really analyse them".[12] Armstrong harvested his images from the liminal space between waking and sleeping, the dynamic potential between the inner imagination of the psyche and the reality of the exterior world, and he saw this in distinctly Freudian terms. Speaking to Coster of the *Evening Standard*, he argued "My theory is that, as the digging up of Greek statues was responsible for the first Renaissance, so the digging up of the unconscious by Freud and the other boys is starting another Renaissance".[13] The eruption of unpredictable, latent desires and fears into everyday life underscores the immanence and potential at the heart of Armstrong's work.

In an article for *The Studio* in 1958, Armstrong described the realisation of the dream-imagery in painted form: "I paint what comes into my mind and to paint without visualizing the final result is impossible to me. The image must be clear and a constant attempt made to keep it from being overlaid with afterthoughts".[14] There is no element of chance – "chance lies in the original conception" – and hence Armstrong's practice comes remarkably close to André Breton's definition of Surrealism as "psychic automatism in its pure state" in the first Surrealist manifesto of 1924.[15] The compulsion for a fully formed image prior to laying down paint was practical as well as political. Working in egg tempera which was his primary choice of medium up until the early 1950s at which point oil took precedence, necessitated a decisive attitude due to its quick-drying nature. Writing in a 1946 catalogue to accompany a group tempera exhibition, Armstrong explained "tempera is a medium for those who have made up their mind. It demands an image in the brain, a predetermined design to be set down touch by touch from beginning to end."[16]

1 THE GODDESS c.1937

John Armstrong's solo exhibition in December 1938 was his first one-man exhibition since 1929. With the exception of his activities as a member of Unit One, Armstrong had primarily dedicated the 1930s to his work in the performing arts, as a set and costume designer for film, theatre and ballet productions. He worked with luminaries of the arts world, including Alexander Korda, the legendary film producer, the choreographer Sir Frederick Ashton and the composer Sir William Walton (also famed for pinning a herring to a Miró object on the opening night of the 1936 Surrealist exhibition at the New Burlington Galleries). Armstrong's 1938 exhibition was one of two halves – the first half consisted of paintings directly inspired by the Spanish Civil War of crumbling houses and abandoned streets. The second comprised work that formed in essence a coda to his multi-faceted design oriented practice of the 1920s and 1930s. During this early period of his career, Armstrong produced many elaborate and decorative murals for the London homes of society figures, such as Lillian and Samuel Courtauld, for the infamous London cabaret club founded by Elsa Lanchester, The Cave of Harmony, and for various hotels owned by Tom Laughton, brother of Charles. These murals and decorative panels were often populated by wild animals and exotic, mythological figures inspired by the ancient world. Armstrong was well versed in the classical world, studying Classics from an early age at St Paul's School, visiting the antique exhibits at the British Museum and cemented by his years spent during World War I in the Royal Field Artillery in Egypt and Macedonia, experiencing the wonders of classical civilization at first-hand.

The Goddess was a highlight from this second half of the exhibition, a strikingly bold, icon-like painting. The work occupies a unique transitional position at this stage of Armstrong's career, as both the culmination of his earlier, decorative work whilst also, with the presence of the feather in the goddess's hand, foreshadowing the anthropomorphic, surrealist work to follow. A formidable Ancient Egyptian or Macedonian-like goddess with hard eyes and a cruel smile faces us straight on, demanding our attention or perhaps our fearful devotion. Against a red background, the colour of fire and blood, and symbolic of vital life forces, of human ferocity and passion, she possesses both masculine strength with her engorged bicep muscles and a womanly seductive form.

The highly distinctive frame with a silvered serrated inner section echoing the goddess's hairstyle is Armstrong's original. Armstrong was meticulous with the framing of his pictures, establishing a collaborative relationship with picture framer Robert Sielle. In an article in The Studio in 1939 entitled 'My Paintings and Their Frames', Armstrong chose The Goddess as the perfect example to illustrate his method of framing his paintings to complement and enhance composition and colour.

The Goddess c.1937

Signed with initials JA lower right
Tempera on gesso on board
63.5 × 43 cm / 25 × 16⅞ in

Provenance

Lord and Lady Strauss
(formerly Mrs Benita Armstrong)

Private Collection

Literature

J. Armstrong, 'My Paintings and their Frames', in The Studio (vol. 117, Jan-June 1939), pp. 142-145, illustrated.

A. Lambirth, A. Armstrong and J. Gibbs, John Armstrong: The Paintings (London, 2009), cat. no. 176, colour illustration p. 170.

Exhibitions

1938 London, Alex Reid & Lefevre Gallery, John Armstrong (38)

1965 London, Marlborough Gallery, Art in Britain 1930-1940 centred around Axis Circle Unit One (8)

1975 London, Royal Academy, John Armstrong 1893-1973 (63)

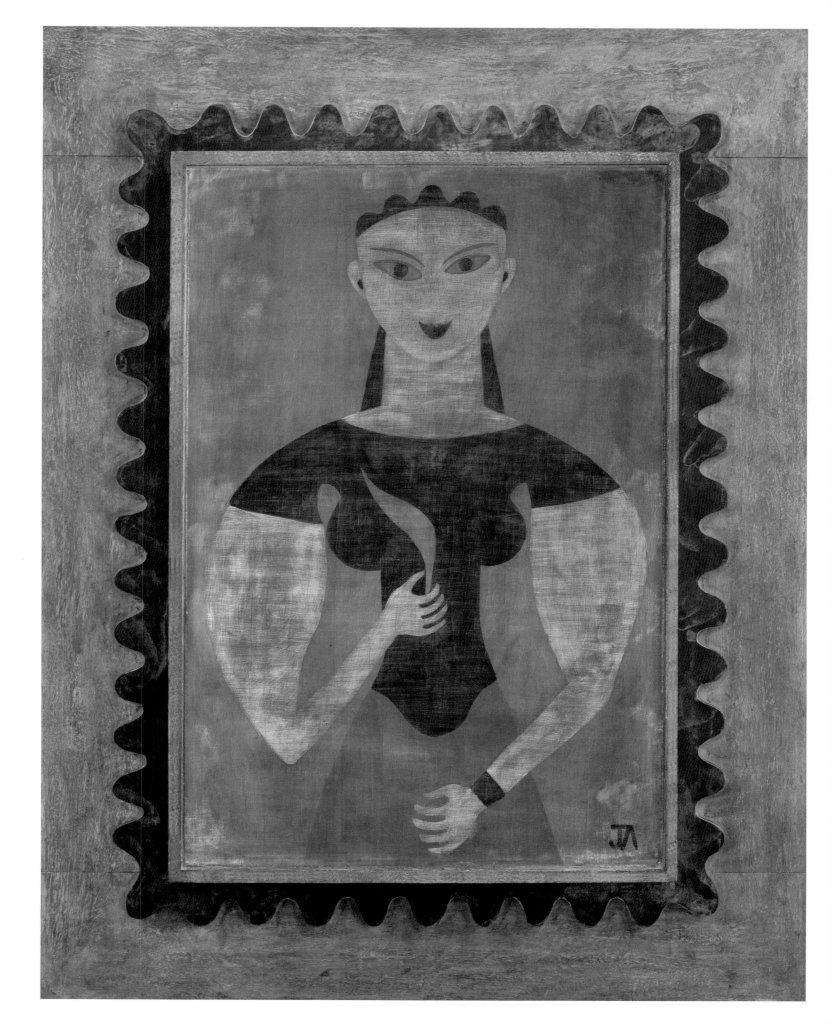

2 ENCOUNTER IN THE PLAIN c.1938

The political segment of Armstrong's 1938 exhibition was steeped in restrained fear brought about by the atrocities of the Spanish Civil War. Numerous British artists, particularly the Artists International Association (AIA), vociferously supported the Republican cause through fund-raising exhibitions. Alongside Armstrong's famed depictions of decaying and destroyed houses, he produced a trio of outstanding works featuring sightless women: *Dreaming Head*, 1938; Tate, [fig. 3], *Heaviness of Sleep*, 1938; Middlesbrough Institute of Modern Art, and *Encounter in the Plain*. In *Encounter in the Plain* a monumental blindfolded woman of statuesque womanly physique, with her head literally in the clouds, dominates a near-barren landscape. Her blindfold renders her oblivious to the road lined with tombstones at her feet, leading to a distant village atop a rock formation, whilst behind her the white cliffs of Dover loom in the middle of the desert-like plain. An unsettling environment intimates an unknown, unseen threat: distorted scale prevents any sense of perspective whilst objects including the shell-like form in the foreground and the white flag (perhaps the flag of surrender) suggest an inexplicable symbolism.

Armstrong never officially joined Surrealism, but his work was closely aligned to Surrealist practices and politics, as noted in almost every review of his 1938 show. In the 1930s, the British Surrealists were a mutable, unstable group, what Michel Remy has termed "a forum of spectral voices", particularly as the rise of Fascism in Spain, Italy and Germany forced many artists to emigrate to London and New York, throwing international Surrealism into flux.[17] As with *The Goddess* [cat. 1], the daunting female figure of *Encounter in the Plain* is Surrealist to its core: the symbol of woman was at the very heart of Surrealism, the embodiment of love and desire, fear and death. From the outset, the Surrealists were infatuated with murderesses and the female hysterics and schizophrenic patients of famed French psychiatrist and teacher of Freud, Dr Jean-Martin Charcot (1825-1893). The artist's muse and unattainable object of corporeal desire, she was everything the cold, rational, logical world of man was not – she offered the potential for a new, surreal, mode of existence that united mind and body, yet she was volatile, threatening, even dangerous. Magritte's *The Lovers*, 1928, 'wrapped' in a passionate embrace, exemplify this fusion of death and desire, locked in an act of erotic suffocation. Armstrong's blindfolded woman becomes emblematic of this dualism: her overtly womanly form only serves to magnify her ominous enormity. The acme of Armstrong's political works from the 1938 exhibition, *Encounter in the Plain* stands amongst the most powerful and significant works of inter-war British Surrealism.

Encounter in the Plain c.1938

Signed with initials JA lower right
Tempera on board
52.1 × 40.6 cm / 20½ × 16 in

Provenance

Lord and Lady Strauss
(formerly Mrs Benita Armstrong)

Private Collection

Literature

A. Lambirth, A. Armstrong and J. Gibbs, *John Armstrong: The Paintings* (London, 2009), cat. no. 183, colour illustration, p. 61.

Exhibitions

1938 London, Alex Reid & Lefevre Gallery, John Armstrong (10)

1975 London, Royal Academy, John Armstrong 1893-1973 (50, The Blind Woman)

1989 Milan, Palazzo Reale, I Surrealisti (without no., The Blind Woman)

1989 Frankfurt, Schirn Kunsthalle, Die Surrealisten (without no., The Blind Woman)

2014/15 Chichester, Pallant House Gallery, Conscience and Conflict: British Artists and the Spanish Civil War

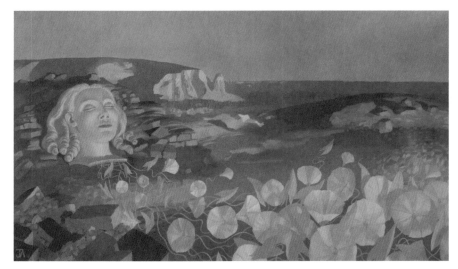

Fig. 3. *Dreaming Head*, 1938; Tate

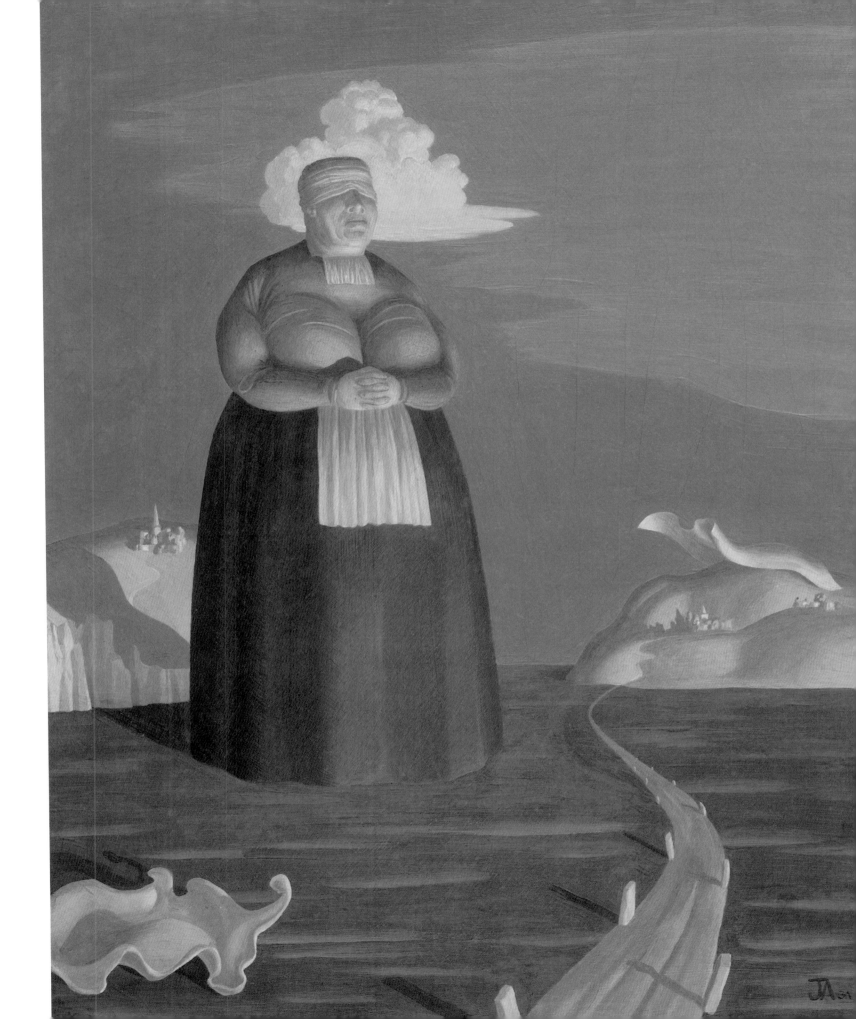

3 SEAWEED GATHERERS 1944

1944 marked the start of Armstrong's experimentation with adopting the "divisionism" technique in tempera, developing a sustained and highly individual method. *Seaweed Gatherers* represents an early product of his brick-like brushwork. The practice has been described with various terminology: in reviews at the time it was simultaneously compared to mosaics (*Reynolds News*), although Armstrong disliked this description, sand-paper (*The Times*), pointillism (*New Statesman and Nation*) and lozenges (*Studio*).[18] Armstrong developed this technique by first applying a layer of dark paint and then, using a square-headed brush, covering the surface with quite broad, smooth, regulated dabs of paint.

Touches of paint invigorate the surface of *Seaweed Gatherers*, vitalising it with a quivering vibrancy. Strokes of blue and yellow form the sky, whilst delicate blocks of single shades constitute each seaweed gathering figure in yellow, cream, pink and brown. The paint itself contributes to the movement within the composition, underlying the sinuous curves of the classical, monumental figures of the seaweed gatherers who seem suspended in an elegant dance. The sinuous folds of the gatherers' robes, realised in delicate shading belying the complexity of the "divisionism", echo the shape of the kelp-like seaweed held up for our appreciation by the main figure.

In an extended poem, Armstrong ruminates on the mysteries of marine organisms, and it is particularly seaweed that dominates: "All is possessed by the slow fingered weed". Experiencing the sea from a fish's eye-view, he continues:

Now only loose weed drifts like a bunch of ribbons;
O the richness of the weed, velvet some, dark red,
Some pleasant green with gold sap in their veins,
O sophisticated lobes, some ghosts,
Swirling with the purity of white linen;
Sway in green dreams to the rhythm of the weed.[19]

Seaweed Gatherers 1944

Signed and dated lower right
Tempera on board
52.1 × 77.5 cm / 20½ × 30½ in

Provenance

Lefevre Gallery, where purchased by
Major Maurice Cooke in 1947

Private Collection

Literature

A. Lambirth, A. Armstrong and J. Gibbs,
John Armstrong: The Paintings (London, 2009),
cat. no. 265.

Exhibitions

1945 London, Lefevre Gallery, Recent Paintings by
John Armstrong and Sine Mackinnon (1)

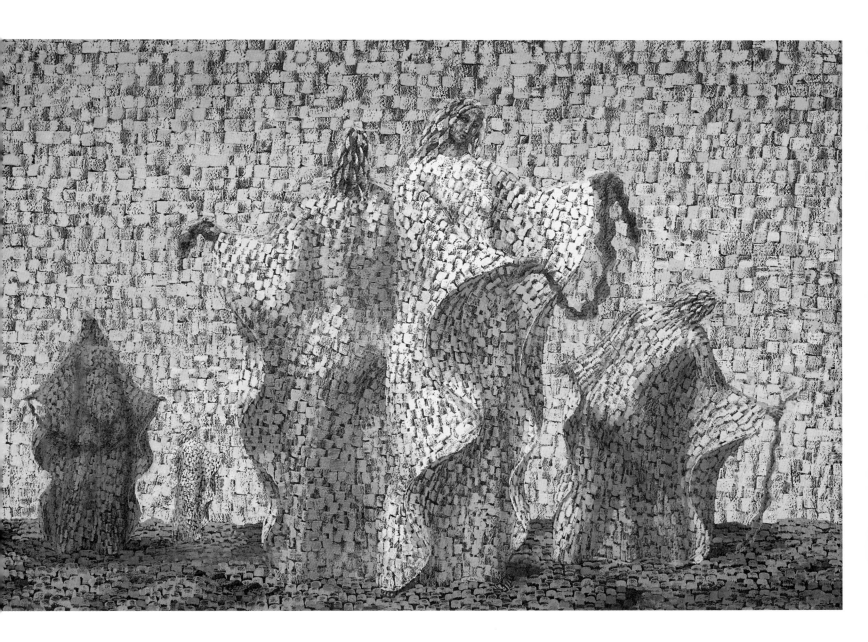

4 BACCHANALE 1944

The imagery of lengths of curling seaweed as imagined in *Seaweed Gatherers* [cat. 3], not the most evidently romantic of organic matter, clearly caught Armstrong's imagination, inspiring a collection of paintings with bending, curving, dancing figures of classical grace placed in serenely balanced, harmonious compositions. Perhaps unsurprisingly for an island nation, the mysteries of the underwater world and the coastal landscape frequently featured in British Surrealist imagery. Armstrong's turn to marine life to uncover surreal, enigmatic forms was paralleled in the work of his Unit One colleagues, Paul Nash and Edward Wadsworth. From the bleak coastlines of Dymchurch and Rye to the decaying Victorian seaside town of Swanage to the French coastal town of Toulon, the sea held an insatiable appeal for Paul Nash. During the 1930s Paul Nash and fellow Surrealist Eileen Agar travelled the Dorset coastline, cameras in hand, photographing coastal ephemera and beach debris. Experimenting with camera angles and framing devices, Nash and Agar explored the disconcerting effect of unexpected cropping and the disjuncture of inexplicable angles. Wadworth's harbour scenes of the late 1930s and 1940s, such as *Anticyclone*; Newport Museum and Art Gallery [fig. 4], likewise play with scale, perspective and unexpected juxtapositions of beach objects – fish, lobsters, starfish, buoys, ropes and anchors. Arrayed in lyrical compositions painted in tempera, like Armstrong, these inanimate objects adopt human characteristics. The organic and inorganic merge in surreal anthropomorphism, and suggestions of elaborate dances abound.

Part of this series beginning with *Seaweed Gatherers*, and among the most poetic, *Bacchanale* makes explicit the connection to the ancient world in title and content. A group of four figures are gathered in a Mediterranean landscape, with an olive tree in the background. Perhaps a meditation on the corresponding harmony of art and music, one figure plays the lyre, whilst the remaining three perform an elegant dance in a manner far removed from bacchanalian. Armstrong delights in pure formal beauty in *Bacchanale*. Writing to a collector in 1953, Armstrong explained that formal qualities were of utmost significance in making a work successful: "What makes it a good picture if, as we both suppose, it is one, are the colour first... and finally the sweep of the composition".[20] In *Bacchanale*, colours of the robes gradate from pale cream to yellow, peach to rosy red across the picture whilst sinuous curving lines draw the eye from upper left to lower right in a sweeping flow of delicate movement. Armstrong clearly deemed the composition a success, returning to it with a further, smaller version in 1945 also entitled *Bacchanale*.

Bacchanale 1944

Signed with initials JA and dated lower right
Tempera on board
47 × 64.8 cm / 18½ × 25½ in

Provenance

The Mayor Gallery, where purchased by
Gordon Watson

Agnews

Private Collection

Literature

A. Lambirth, A. Armstrong and J. Gibbs,
John Armstrong: The Paintings (London, 2009),
cat. no. 280, colour illustration, p. 183.

Exhibitions

1945 London, Lefevre Gallery, Recent Paintings by
John Armstrong and Sine Mackinnon (31)

1984 London, New Grafton Gallery, Barnes,
John Armstrong (3, Helicon)

Fig. 4, Edward Wadsworth, *Anticyclone*, Newport Museum and Art Gallery

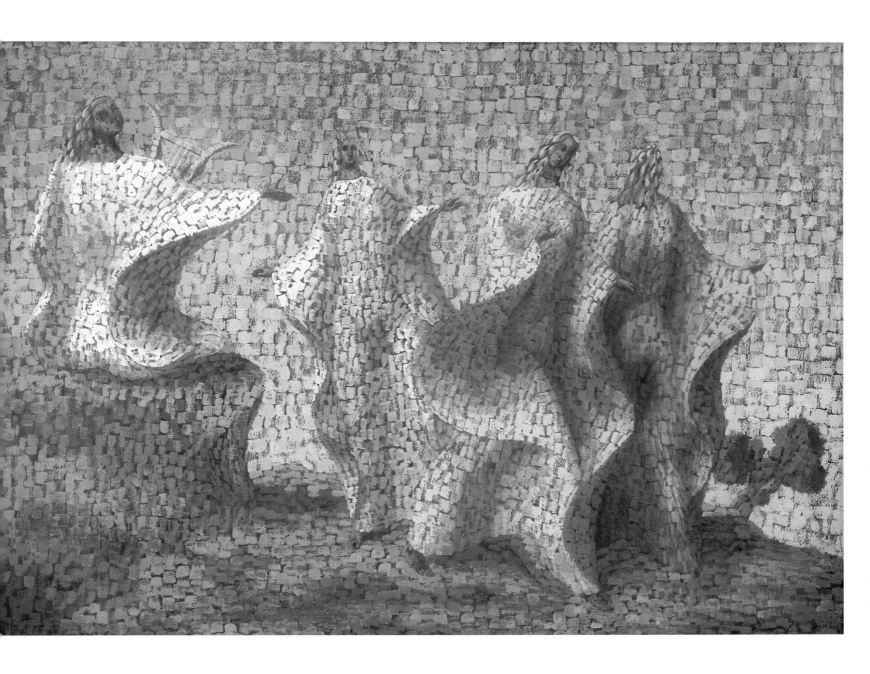

5 FIGURE IN CONTEMPLATION 1945

After its closure during the war, Lefevre re-opened in 1945, and John Armstrong had his first exhibition in seven years in early July 1945. Works in his "divisionist" style dominated the show, a veritable array of pulsating canvases, populated by monumental, classical figures in the guise of *Seaweed Gatherers* and *Bacchanale*, often with titles suggesting ancient mythological sources. A series of ten, perhaps eleven, paintings in the exhibition, most of which are now in public collections, featured such figures, draped in flowing robes, wandering amidst classical buildings. These elegant figures are dwarfed by towering, broad open apses, interspersed with niches and arches, and supported by simple Doric columns, whilst extended arcades lead back with plunging perspective. The complex compositions of these paintings and the fascination with the interaction between painting, sculpture and architecture reveal the influence of Giorgio di Chirico, another artist who was surreal without being Surrealist.

In *Figure in Contemplation* a lone man, deep in thought - perhaps Aristotle's contemplative man who has achieved pure rational thought - walks in a deserted piazza. All sense of scale and perspective is distorted, emphasising the huge chasm of space engulfing the solitary philosopher. The composition of architectural elements, with dramatically cropped structures in the foreground framing the towering central apse, is compositionally exquisitely surreal, whilst the presence of one diminutive figure heightens the uncanny emptiness of the painting. Perhaps the melancholic absence in *Figure in Contemplation* reflects an international meditation on sacrifice and loss, legacies of war.

Figure in Contemplation, and indeed the series as a whole, seems an extended rumination on the intrinsic connection between man and architecture - the innate need of man for shelter and the effect of a stimulating environment upon its inhabitants. Modernist architecture, and particularly his admiration for his Unit One colleague Wells Coates, was intrinsic to Armstrong's turn to Surrealism: writing in the Unit One catalogue, Armstrong described his realisation "that art had always to have...a lift by the scruff of the neck from architecture in order to achieve anything".[21] In an undated letter, Armstrong describes to the recipient the beginnings of architecture in the ancient world: "Some man by looking at and appreciating a tree invited the first column. In a treeless world neither the Parthenon or Salisbury cathedral would have been built."[22] Such a story of the origins of architecture as founded upon the human form derives directly from Roman architectural theorist Vitruvius, whom Armstrong would inevitably have studied during his school days. The architectural series speaks of the interconnectivity of the organic, inorganic and human, a pantheistic union. The quintessential features of classical architecture – symmetry, repetition, harmony and balance – are echoed in the balance of delicate pastel colours applied in restrained blocks of paint in "divisionist" style.

Figure in Contemplation 1945

Signed with initials JA and dated lower left
Tempera on board
45.7 × 66.7 cm / 18 × 26 1⁄4 in

Provenance

Private Collection

Literature

A. Lambirth, A. Armstrong and J. Gibbs, *John Armstrong: The Paintings* (London, 2009), cat. no. 297, black and white illustration, p. 184.

Exhibitions

1945 London, Lefevre Gallery, Recent Paintings by John Armstrong and Sine Mackinnon (35)

Fig. 5, *Figure among Buildings*, 1945; Bristol Museum & Art Gallery

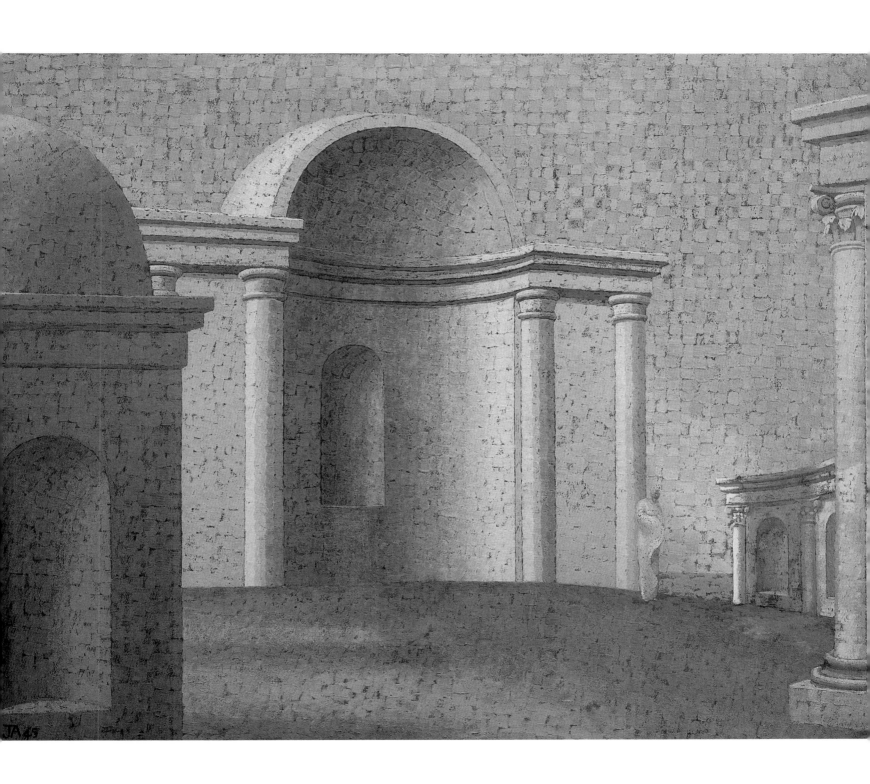

6 MADONNA 1945

The series of dancing classical figures and the architectural series which together dominated Armstrong's 1945 exhibition reach their exquisite culmination in a duo of works from 1945, *Faith*, depicting Jacob wrestling the angel, and *Madonna*. Latent religious references evident in titles of the architectural series – *Garden of Contemplation* referencing the Garden of Eden or Gesthemane, *Lament for Icarus* suggestive of the lamentation over the body of Christ – are here made evident. Following the traditional motifs of Medieval and Renaissance altarpieces, the Madonna and Child are enthroned and flanked by two figures that gesture in a theatrical manner towards the seated pair. Although ostensibly a religious painting, Armstrong utilises the recognisable scene to consolidate his previous experimentations of the painted relationship between the human figure and its architectural setting. The stone niche of Gothic arches is a favoured setting for earlier works, whilst the gesturing attendants, far from saints, are Armstrong's classical figures in the style of the *Seaweed Gatherers* [cat 3]. A relatively traditional triangular composition, articulated by gestural movement and the curving folds of robes, produces a painting of serenity and harmony.

Armstrong was not alone in adopting the Madonna and Child theme for its compositional and formal qualities. His Unit One colleagues Barbara Hepworth and Henry Moore both explored the mother and child from the 1930s onwards, and in 1943 Moore was commissioned to carve a Madonna and Child for St. Matthew's Church in Northampton [fig. 6]. Moore explained that, "From very early on I have had an obsession with the Mother and Child theme. It has been a universal theme from the beginning of time…I suppose it could be explained as a "Mother" complex".[23] The Mother/Madonna and Child, an ostensibly traditional motif, was explored with an avant-garde approach for both the formal and intimate interaction of two figures, thus becoming a recurrent subject of inter-war British Modernism. Armstrong's architectural series for his 1945 solo show is redolent with intimations towards the work of his contemporaries, particularly sculptural elements in the vein of both Moore and Hepworth, whose hollow sculptures interlaced with string appear repeatedly in monumental scale.

Madonna is a supremely beautiful example of Armstrong's early "divisionist" style, and on a larger scale than his usual compact sizing. Set against a dark under-layer of paint, broad yet controlled touches of dry tempera paint cover the surface in shimmering gradations of colour. As with *Seaweed Gatherers*, colour is uniform for distinct forms, so that each element of dense colour glows– touches of red delineate the arches of the architectural niche, whilst the Madonna is clad in luminous lavender and peacock blue robes. Monumental yet delicate, *Madonna* is elegant, vibrant and resplendent – Armstrong at the peak of "divisionist" prowess.

Madonna 1945

Signed with initials JA and dated lower right
Tempera on board
76.2 × 76.2 cm / 30 × 30 in

Provenance

Lord and Lady Strauss
(formerly Mrs Benita Armstrong)

Private Collection

Literature

A. Lambirth, A. Armstrong and J. Gibbs, *John Armstrong: The Paintings* (London, 2009), cat. no. 309, colour illustration, p. 186.

Exhibitions

1950 London, Whitechapel Art Gallery, Painters Progress (44)

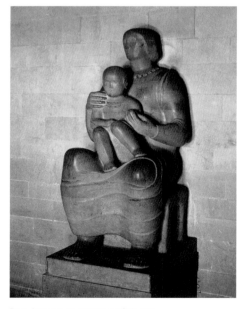

Fig. 6. Henry Moore, *Madonna and Child*, 1943; St Matthew's Church, Northampton

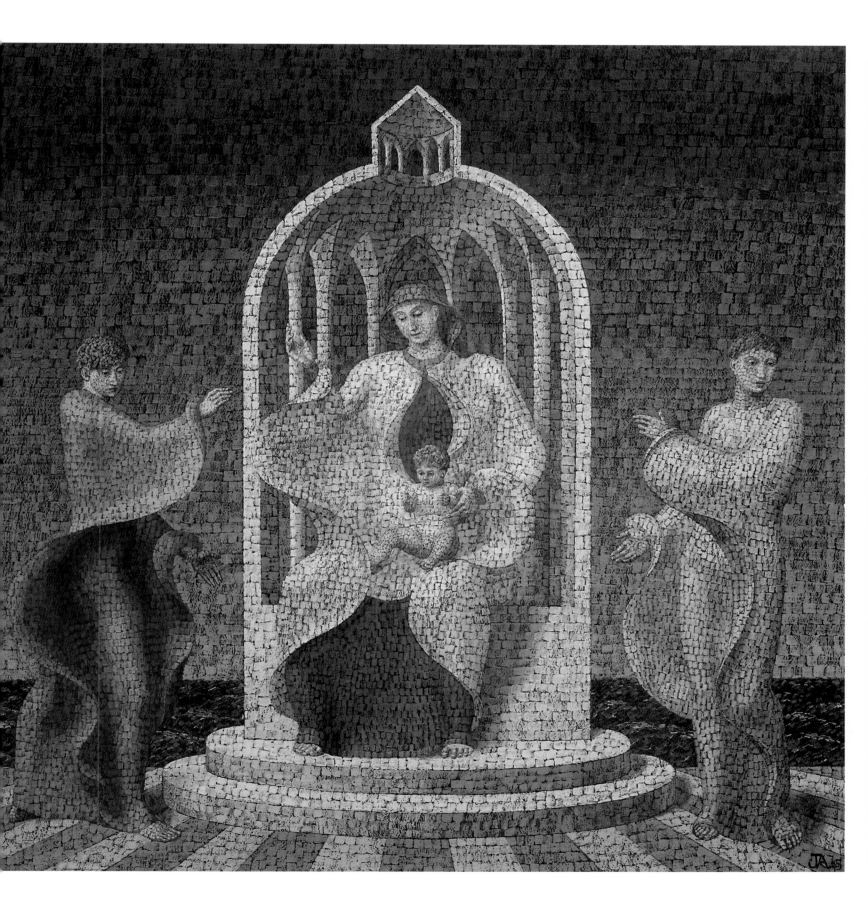

7 FEATHERS CONCLAVE 1946

Having spent the war years in Essex, by the end of 1945 Armstrong was installed in Oriental Cottage in Lamorna, Cornwall with his second wife, Veronica. An extraordinary place of exotic flora and fauna due to the balmy microclimate, Lamorna precipitated some of Armstrong's most evocative, bold imagery of anthropomorphic organic forms, which live, grow and transform. As Paul Nash so famously argued, British Surrealists made manifest a pre-existing 'superreality' in the British landscape.[24] Individual artists were drawn to sites of psychic or mythological significance across the country: Paul Nash and Eileen Agar to the ancient rocks of Dorset, Graham Sutherland and John Piper to the Welsh landscape. Also resident in Lamorna was the deeply individual British Surrealist Ithell Colquhoun, whose interests resided in the occult, myth and alchemical transformation. In her mystical tract on the region, *Stones of Cornwall*, Colquhoun details the giddy amalgamation in Lamorna of supernatural wildlife, Arthurian legend, provincial folklore, religious symbolism, Druidism, witch-covens and alchemical potential, all of which has its basis in the very "structure of its rocks [which] gives rise to the psychic life on the land".[25]

The statuesque figures that populated Armstrong's 1945 Lefevre exhibition morphed over the subsequent two years into anthropomorphic forms of feathers, leaves, and shells. Still animated with classically monumental presence and contrapposto sinuous curving frames, it was evident that Armstrong was immersing himself yet further into symbolism and allegory. Originally titled *Feathers*, *Feathers Conclave* represents one of Armstrong's earliest ambitious group compositions of an assemblage of erect feathers, gathered in a positive riot of exquisite pastel colours. In *Stones of Cornwall*, Colquhoun dedicated a chapter to describing the multitude of birds in Lamorna, claiming "the pink, russet, bronze-green and Sèvres-blue of a chaffinch is never so glossy as here".[26]

In light of Armstrong's increasing political activism and vocal pacifism during the late-1940s – he designed the front-cover for the Labour party manifesto for their successful 1945 election campaign – *Feathers Conclave* takes on a subtly anti-war meaning. The feathers stand to attention, like a battalion of soldiers, but during both world wars feathers were handed to conscientious objectors to draw the attention of the general populace to their cowardice. The contrast between the soldier-like, even confrontational demeanour of these feathers and the reality of feathers' lightness lends the painting a surreal humour characteristic of Armstrong's anthropomorphic work. There is a certain theatricality to *Feathers Conclave* – the unit of feathers, dazzling, luminous and graceful, is staged for our delectation.

Feathers Conclave 1946

Signed with initials JA and dated lower right
Tempera on board
45.5 × 66 cm / 17 7/8 × 26 in

Provenance

Private Collection

Literature

A. Lambirth, A. Armstrong and J. Gibbs, *John Armstrong: The Paintings* (London, 2009), cat. no. 330 (as Feathers), colour illustration, p. 188.

Exhibitions

1947 London (probable), Lefevre Gallery, New Paintings by John Armstrong (9)

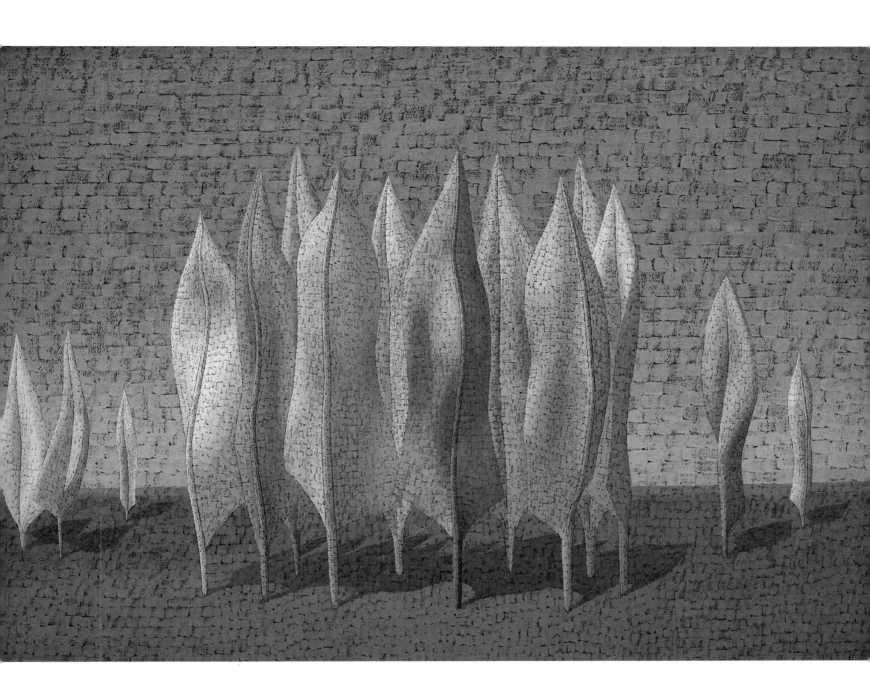

8 THE ICEBERG 1946

Merging architectural elements of earlier works with the anthropomorphic motifs that populated Armstrong's output of the late 1940s, *The Iceberg* is a work of understated mystery, enigmatically surreal and evocatively suggestive. Feathers, assembled in distinct small groups, stand guard around and survey a fortress-like floating iceberg, reflected in a perfectly still ocean. The eponymous iceberg is inspired by the dragon's lair in the early Renaissance painting *St George and the Dragon* by Florentine artist Paolo Uccello (1397-1475) in the National Gallery, London [fig. 7]. With its gothic arcading the iceberg is an extraordinary construction, surely suggesting the sunny pleasure-dome with caves of ice of Kubla Kahn in Samuel Taylor Coleridge's hallucinatory poem. Peculiar shapes interlock in *The Iceberg* – the ice-cave, the cliff precipice, the feathers and their shadows all intermingle and overlap on the surface of the painting.

The layers of illusion in *The Iceberg* are complex – the iceberg may have a 'real' source in Uccello's *St George and the Dragon* but that is a painted representation of the product of another artist's imagination. Armstrong's visual quotations and repetitions in *The Iceberg* situate his work firmly within a Surrealist practice: the use of signifiers that are paradoxically referential addresses the problem of representation and resemblance inherent in the very act of painting. Of the Surrealists, René Magritte conducted the most sustained investigation into meaning and symbolism - similarities between the work of Magritte and Armstrong abound, particularly in their respective interest in anthropomorphic transformation. Simultaneous with Armstrong's Lamorna-inspired leaves and feathers, Magritte was producing paintings of surreal landscapes populated by monumental erect skeletal leaves [fig. 8]. Uniting in *The Iceberg* the concerns of international Surrealism with his personal experience of the Lamorna landscape, Armstrong produces a work of delicate beauty and surreal complexity.

By the end of 1946, Armstrong was painting in two "divisionist" modes. With the first of these, the original style of *Feathers Conclave* [cat. 7], the surface of the paint was broken up by relatively broad dabs of paint. *The Iceberg* represents the evolution of a more subtle approach whereby the surface remains relatively uniform but a variety of small touches of different colours unite in one form. Such an intermixture gives *The Iceberg* a tonal depth and warmth, a luminosity of colours combining in the eye. Decidedly autumnal tones dominate the canvas – yellow, burnt orange and pink-brown feathers are complemented by the pale cream of the iceberg and the warm blues of sky and sea.

The Iceberg 1946

Signed with initials JA and dated lower right
Tempera on board
43.2 × 59.7 cm / 17 1/8 × 23 1/2 in

Provenance

Private Collection

Literature

A. Lambirth, A. Armstrong and J. Gibbs, *John Armstrong: The Paintings* (London, 2009), cat. no. 329, colour illustration, p. 188.

Exhibitions

1947 London, Lefevre Gallery, New Paintings by John Armstrong (8)

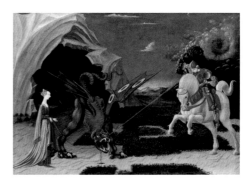

Fig. 7, Paolo Uccello, *Saint George and the Dragon*, c. 1470; National Gallery, London

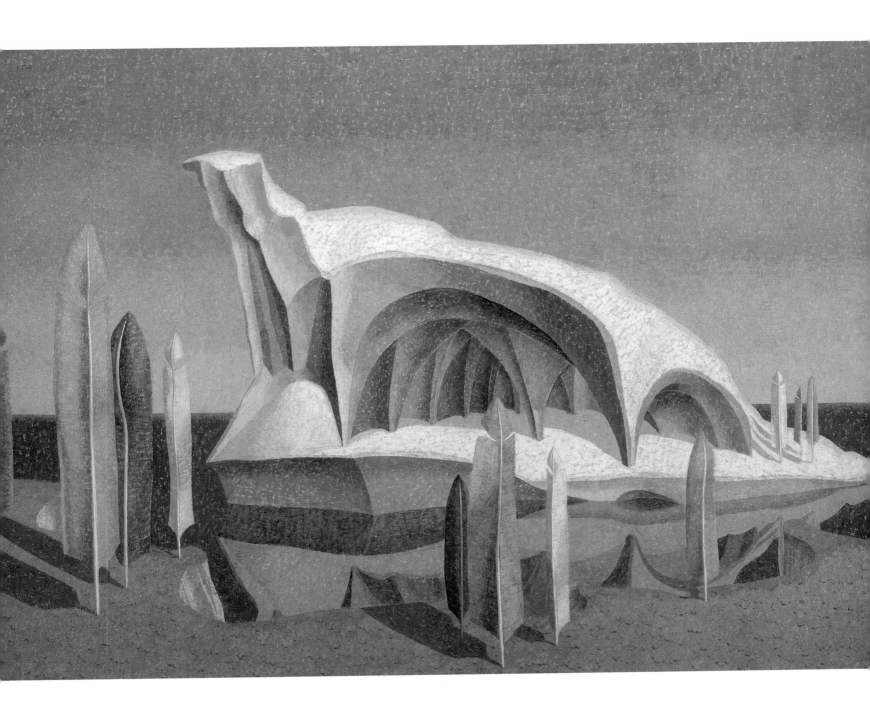

9 THE PASSION OF THE INANIMATE 1947

The feathers that populated Armstrong's output in 1946 transformed in the
following year into anthropomorphic leaves, veined, brittle and frequently
disintegrating. Forming a particularly disquieting series that hung in the 1947
Lefevre show alongside the feather works, these so-called 'Embrace' paintings
are set in the depths of night in otherworldly, barren, cratered landscapes. Dusky
pink and brown leaf forms emerge from inky blue night skies, yet shadows eerily
fall across the paintings.

The Passion of the Inanimate is the most starkly powerful of the 'Embrace' series.
A lone leaf-feather hybrid stands isolated in rocky terrain. The intimacy of the
confrontation is striking. The leaf fills the space, staring us down in an unapologetic
encounter. The title contains an impossible paradox - how can an inanimate leaf
experience any emotion, let alone one as forceful as passion? The realisation
of seemingly incompatible elements into the imagery of a leaf possessing such
evidently human characteristics is decidedly uncanny. Freud's essay on *The
Uncanny* was published in 1919, and was of immense significance to the Surrealists.
In *The Passion of the Inanimate* uncanny transgressions are made manifest. The leaf
occupies a liminal space between organic and inorganic, living and dead, real and
imagined, part object (leaf) and whole (tree) – an image that is hauntingly
beautiful.

The influence of D'Arcy Wentworth Thompson's fashionable 1917 zoological tract,
On Growth and Form, which famously inspired Richard Hamilton's 1951 eponymous
Festival of Britain installation, is strongly felt. D'Arcy Thompson opens *On Growth
and Form* arguing that the "search for differences or fundamental contrasts
between the phenomena of organic and inorganic, of animate and inanimate
things, has occupied many men's minds...and the contrasts are apt to loom too
large".[27] D'Arcy Thompson's embrace of an all-encompassing, inter-connected
natural environment tapped into a certain zeitgeist, of which Armstrong was an
avid proponent.

The Passion of The Inanimate 1947

Signed with initials JA and dated lower left
Tempera on board
72.4 × 53.3 cm / 28½ × 21 in

Provenance

Duncan MacDonald

Private Collection

Literature

'Perspex's choice for the picture of the Month',
Apollo, May 1947

A. Lambirth, A. Armstrong and J. Gibbs,
John Armstrong: The Paintings (London, 2009), cat.
no. 337, colour illustration p. 189.

Exhibitions

1947 London, Lefevre Gallery, *New Paintings by
John Armstrong* (10)

Fig. 8, René Magritte, *Les Barricades Mystérieuses*, 1961; Private Collection

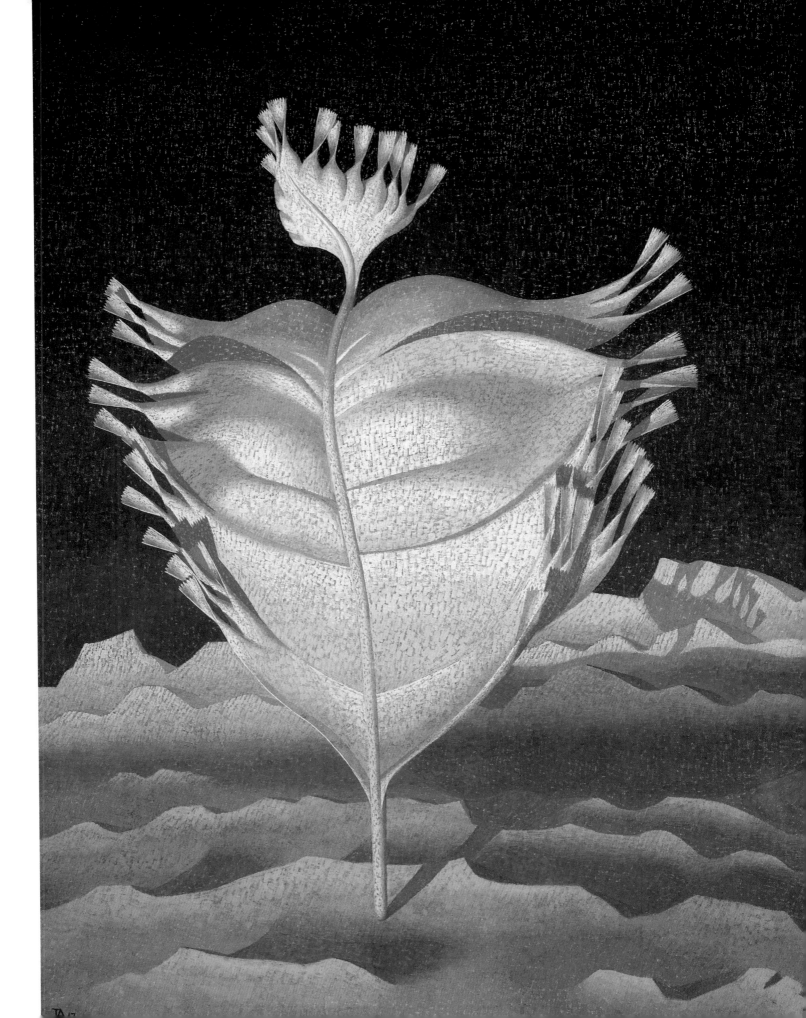

10 LEAF FORMS 1947

Alongside such stark singular imagery as *The Passion of the Inanimate* [cat. 9], Armstrong explored enigmatic interactions and configurations between leaf and feather figures in the 'Embrace' series as with *Leaf Forms*. One upright leaf, no longer a leaf-feather hybrid but recognisably a decaying brown leaf, stands, an austere figure, on a rocky bank above three prostrate leaf companions. The religious insinuation of some titles of the 'Embrace' works – Armstrong's titles are often less ambiguous than the paintings themselves – is here, as with the closely related *Transfiguration*, 1947, [fig. 9] reflected by the imagery. The pose of the outstretched primary leaf, near human in its stance, is palpably reminiscent of a crucifixion scene.

As with Armstrong's other morphological works instigated by the profusion of exotic and overgrown flora in Lamorna, there is a sinister eeriness latent within *Leaf Forms*. The ability of nature to reclaim what was once its own is a continual theme throughout British Surrealist Ithell Colquhoun's book *Stones of Cornwall*. Each layer of history is devoured by the wilderness of Lamorna so that only relics and memories remain. Armstrong's anthropomorphic paintings prefigure the earliest science fiction novels of the 1960s concerned with nature wreaking its revenge on the human race. Often set in dystopian post-nuclear apocalypse worlds, the natural environment mutates into a dangerous, indestructible enemy of the human race.

Bold in composition, *Leaf Forms* is dramatically powerful, yet sustained attention to the work reveals an exquisite subtlety in colour and suggestion in meaning. The standing leaf seems defiant in the face of the advancing, crawling trio below. Theatrical, near spot-lit, lighting, casts deep shadows across the picture, suggesting a setting sun to the right of the picture frame. The stark lighting accentuates the sculptural solidity of the leaves: Armstrong picks out delicate touches of shadow on the upright leaf, cast by its own veining. This leaf is brittle, perhaps even fragile in curious juxtaposition to the menacing sturdiness of the prostrate leaves with prominent veining. With its sculptural monumentality, intense lighting, uncanny anthropomorphism, and elusive relationship amongst the leaves, *Leaf Forms* is Armstrong at the zenith of his Lamorna phase.

Leaf Forms 1947

Signed with initials JA
and dated lower right
Tempera on board
36.8 × 57.2 cm / 14½ × 22½ in

Provenance

S.B. Hainsworth Esq

Private Collection

Literature

A. Lambirth, A. Armstrong and J. Gibbs, *John Armstrong: The Paintings* (London, 2009), cat. no. 347, colour illustration, p. 190.

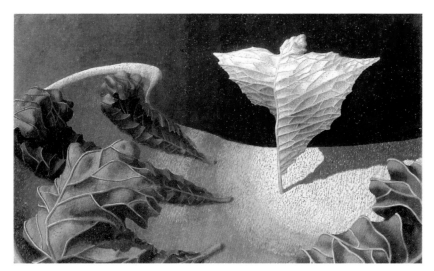

Fig. 9, *Transfiguration*, 1947; Private Collection

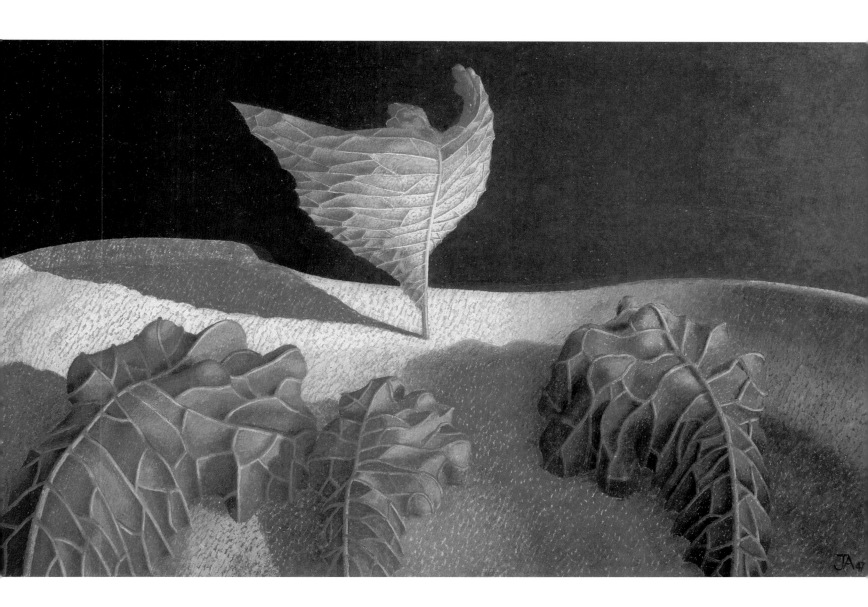

11 THE JOCKEY 1947

The first appearance of Harlequin, a stock clown figure from Italian *commedia dell'arte* of the sixteenth century, in Armstrong's *oeuvre* was in 1941, when he painted himself as Harlequin. From this point onwards Harlequin and clowns became essential characters in Armstrong's output, and were the protagonists of the battle series and related works. Following the famous literary tradition, the clown or fool in Armstrong's politically tinged works represents the only good and truth-telling man in a world full of lies, evil, cowardess and foolish acts. In the introduction to the catalogue for his 1951 Lefevre show, Armstrong expanded on the figure of the clown, writing he is "the image of frustration, fighting battles of nothing, attempting a leap forward but doing a back-somersault instead... [assuming] other aspects of humanity in its predicament".[28] In this sense, Harlequin also becomes the Everyman, tossed in the turmoil of a chaotic world.

The Jockey is very closely linked to the earliest *Harlequin*, 1941, perhaps a self-portrait, and part of a small group of paintings in 1947 including *Bust of Harlequin*, *Pierrot* (another named *commedia dell'arte* character) and *Puppet*. These *commedia dell'arte* figures were frequently used in puppet shows, and evidently Armstrong plays with the connections between puppetry, theatre and folklore stories such as Pinocchio, whilst also foreshadowing the central scarecrow character of his monumental history painting, *Victory*, 195, [cat. 19]. *The Jockey* appears disconcertingly somewhere between human and toy with a wooden nose and glass eyes, wearing jockey silks with the recognisable lozenge patterning of Harlequin. The portrait bust format plays with the Dutch Golden Age genre of the *tronie*, generally depicting an unknown sitter in costume. With the suggestion of a ruff collar and puffed, ruched sleeves Armstrong paints *The Jockey* with tongue firmly in cheek. This select group of puppetry inspired busts are particularly uncanny, with the sitters suspended between animate and inanimate and tinged with shades of the underlying menace of many folklore tales, recalling the Surrealists' fascination with the uncanny 'living doll' of the mannequin. *The Jockey*, as with Armstrong's other harlequin paintings, is a deliberate continuation of an international avant-garde tradition – not just of the Surrealists but also conscious of the legacy of Picasso's Rose Period harlequins.

The Jockey 1947

Signed with initials JA
and dated lower right
Tempera on card
27.9 × 21.6 cm / 11 × 8½ in

Provenance

Lord and Lady Strauss
(formerly Mrs Benita Armstrong)

Private Collection

Literature

A. Lambirth, A. Armstrong and J. Gibbs,
John Armstrong: The Paintings (London, 2009),
cat. no. 352.

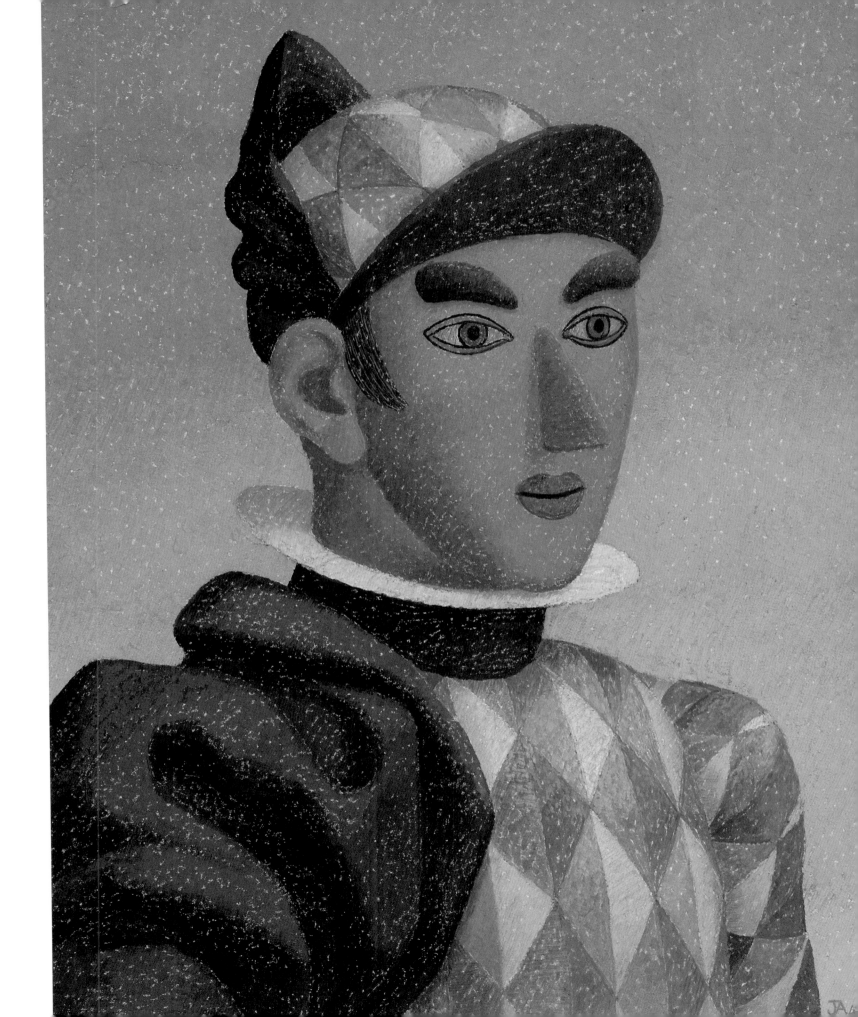

12 THE VISITATION 1949

The second half of the 1940s was a period of great personal happiness and success for Armstrong. Situated in Lamorna with his wife Veronica, and with four shows in eight years from the end of World War II, Armstrong was at the height of his creative powers. Painted in 1949, *The Visitation* is a particularly exquisite painting from Armstrong's St Teresa series, depicting the visions and visitations of St Teresa of Ávila, the sixteenth-century Spanish nun made famous by Bernini's erotic sculpture of her in ecstasy. Spanning from 1946 through to the start of the 1950s, St Teresa's mystical hallucinations seem to represent for Armstrong a suitable personification of the veneer of hysteria in the Cold War era.

In *The Visitation*, a benevolent Christ, robed in white, appears to a nun who is rapt in adoration. With her eyes closed, she is lost in the joy of the vision, as Christ gently touches her hands which she holds aloft to him. The serenity of the highly stylised faces is deliberately evocative of the aesthetics of Byzantine icons but is also reminiscent of Stanley Spencer's devotional painting. The comparison to Spencer is not just aesthetic but also atmospheric – the intimacy, even domesticity, of *The Visitation* in size and restraint is redolent of Spencer bringing biblical scenes to the Berkshire countryside [fig. 10]. Compact and radiant, *The Visitation* glows with an icon-like beauty. The blue of the sea and the blue of the sky combine to form a luminous background against which the opposing colours of the pure white of Christ's robes and the black habit of the nun stand in resplendent contrast.

The Visitation 1949

Signed with initials JA
and dated lower right
Tempera on card
31.1 × 26.7 cm / 12¼ × 10½ in

Provenance

Private Collection

Literature

A. Lambirth, A. Armstrong and J. Gibbs, *John Armstrong: The Paintings* (London, 2009), cat. no. 381, colour illustration p. 195.

Exhibitions

1975 London, Royal Academy, John Armstrong 1893-1973 (104)

Fig. 10, Stanley Spencer, *The Deposition and the Rolling Away of the Stone*, 1956; York Museums Trust

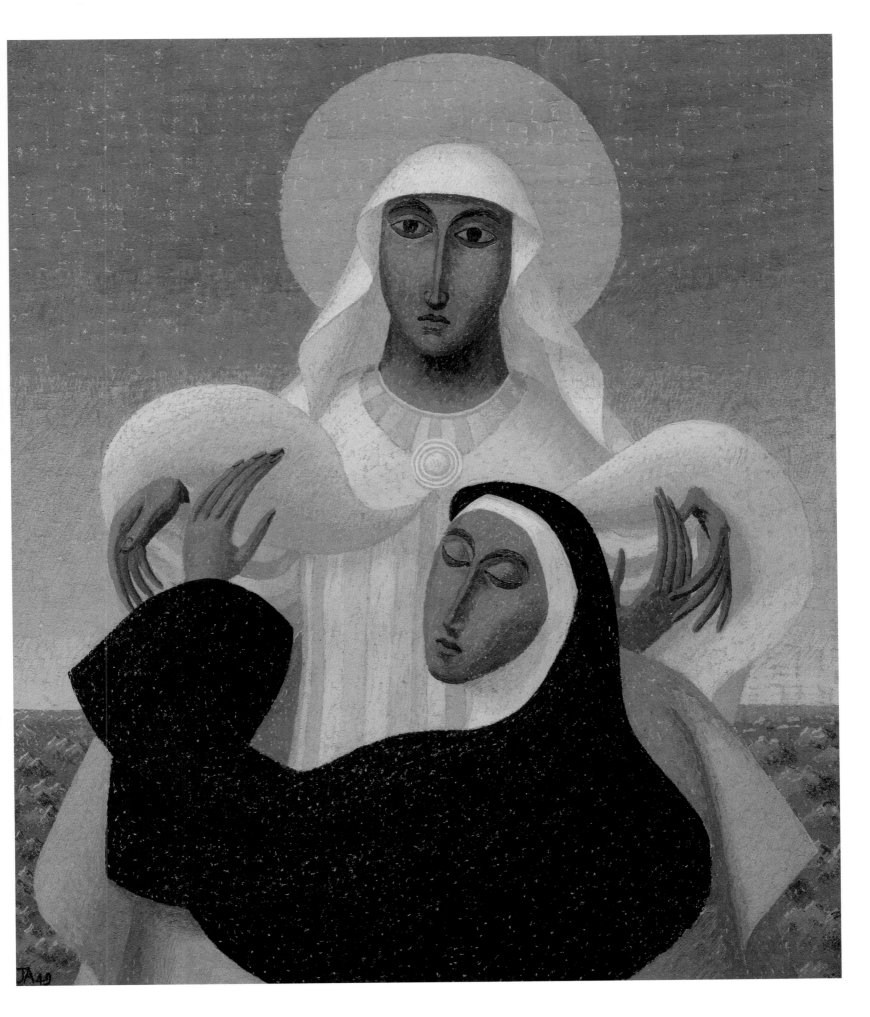

13 THE BATTLE OF NOTHING 1949

Whilst at the conclusion of the 1940s Armstrong was enjoying personal success, on a political front the peace promised by the conclusion of hostilities in 1945 descended rapidly into the Cold War, and the threat of nuclear destruction seemed entirely possible. Fear permeated the artistic world by 1949, the year Armstrong painted *The Battle of Nothing*, the first of his trio of battle paintings. George Orwell's *1984* was published mere weeks before the Soviet Union tested its first atomic bomb. An ardent nuclear disarmament supporter, Armstrong wrote an article in 1950 for the *New Statesman*, entitled "A Thought on Sodom". It opens "Sodom was destroyed in the first air-raid because of the lack of ten righteous men. Is all life on this earth to be destroyed in the final one, because of the lack of a similar proportion of men?"[29]

Intimately related to Armstrong's preceding Harlequin works, such as *The Jockey* [cat. 11], and prefiguring the symbolism of his umbrella works which included *Gaslight* [cat. 14], Armstrong began a series of battle paintings, a small group of works emanating from a central trio, *The Battle of Nothing* followed by *The Battle of Propaganda*, 1953, and *The Battle of Religion*, 1953. The crowning work in the series was Armstrong's extraordinary and prodigious painting, *Storm*, 1951, [fig. 11], painted for the Arts Council's Festival of Britain exhibition. Presented as monumental history paintings in an art historical tradition, these battles are fought by clowns with wooden swords and umbrellas against invisible enemies. As with *The Iceberg* [cat. 8], the influence of Paolo Uccello and his early Renaissance Florentine style looms large, in particular Uccello's trio of martial masterpieces depicting *The Battle of San Romano*, of which *Niccolò da Tolentino* is in the National Gallery in London.

The message of the futility and idiocy of war is palpable and poignant in *The Battle of Nothing*. In 'A Thought on Sodom', Armstrong continues: "General Eisenhower was reported lately in *The Times* as having said: "Far better risk a war of possible annihilation than grasp a peace which would be the certain extinction of free man's ideas and ideals.""[30] Armstrong's choice of quotation, indicative of the atmosphere in which McCarthyism took hold, suggests that the battle is being waged against a non-existent enemy. It is a product of a paranoid imagination, a complex of persecution. In *The Battle of Nothing*, *commedia dell'arte* Pierrot clowns, in baggy pantaloons, pointed caps and drooping ruffs ill-suited as combat uniform, fight an invisible enemy with wooden swords. Caught in an elegant theatrical tableau, precariously positioned on a cliff top, they seem petrified, permanently engaged in curiously dance-like combat of and for nothing. The battle is rendered absurd by the Renaissance-like formal beauty - the harmony of the composition in which each constituent part relates to the whole, the delicate balance of red, black and white of the Pierrots' costumes, the dusky pink aura-like lighting casting soft shadows, and the variety of graceful poses which animate the canvas.

The Battle of Nothing 1949

Signed with initials JA
and dated lower left
Tempera on board
49.5 × 73.5 cm / 19½ × 29 in

Provenance

The Collection of Lord and Lady Strauss
(formerly Mrs Benita Armstrong)

Private Collection

Literature

J. Rothenstein, *Modern English Painters, Volume Two: Nash to Bawden*, (3rd edi., London and Sydney, 1984), p. 155.

A. Lambirth, A. Armstrong and J. Gibbs, *John Armstrong: The Paintings* (London, 2009), cat. no. 379, colour illustration, p. 91.

Exhibitions

1950 London, Whitechapel Art Gallery, Painters Progress (49, Battle over Nothing)

1975 London, Royal Academy, John Armstrong 1893-1973 (105)

Fig. 11, *Storm*, 1951, Private Collection

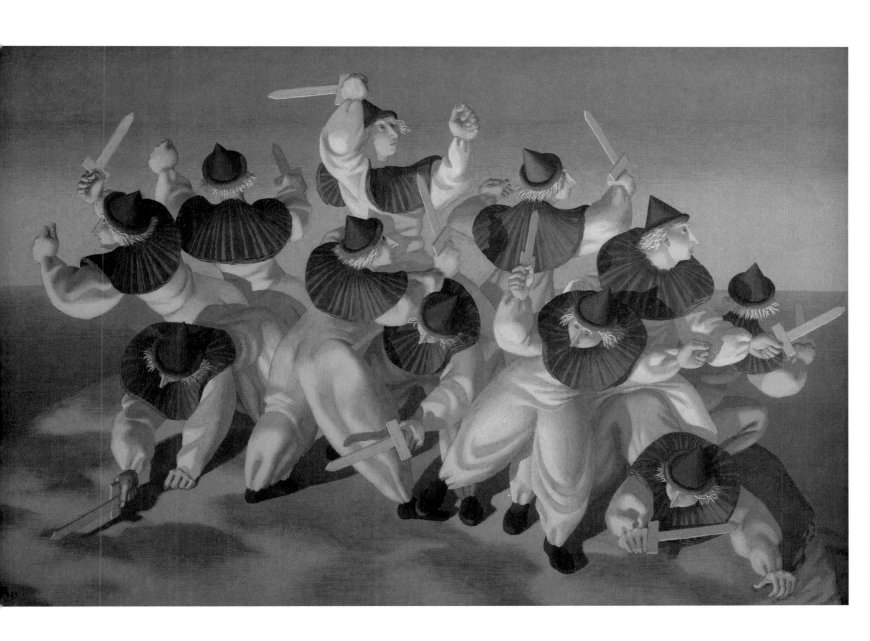

14 GASLIGHT 1952

Armstrong's 1951 solo exhibition at Lefevre was largely dominated by works inspired by his home in Lamorna – exotic, otherworldly flora spring forth in the paintings – but alongside these more decorative works Armstrong was becoming increasingly preoccupied by the threat of nuclear annihilation. Together with the battle series, Armstrong turned to the motif of the anonymity of the city to elucidate the blinkeredness of humanity. In *Gaslight*, over-coat clad men scurry through the lamp-lit streets of a mysterious rain-soaked city. Hidden underneath their umbrellas they are unidentifiable and blind to their fellow city dwellers, unknown and unknowable, each surviving in a cocooned existence.

Umbrellas first appeared in Armstrong's *oeuvre* in 1950, with the painting *Umbrella Men*, 1950, and became an intrinsic element of Armstrong's symbolic language, intimately related to the Everyman, Harlequin and the battle series. He explained their significance to his work in the catalogue for the 1951 show: "they symbolise also the inadequate beliefs under which men attempt to shelter from the growing storm of despair".[31] In *Gaslight* these shelters have become barriers to divide men from one another whilst also blinding them to reality. Armstrong's utilisation of an umbrella has important Surrealist precedents, most obviously in the work of René Magritte but also Max Ernst's famous definition of Surrealism as the "fortuitous encounter upon a non-suitable plane of two mutually distant realities...the chance meeting upon a dissecting table of a sewing-machine with an umbrella".[32] In *Gaslight* rather than eliciting a surreal encounter, the umbrella acts as a physical blockade preventing any meetings or chance happenings that were the bedrock of the political potential of the city in Surrealism.

By 1952 Armstrong had moved away from tempera, the primary medium of his work up to this point, and turned instead to working predominantly in oil. This change is largely inexplicable – it was suggested that he gave up tempera due to the rationing of eggs but his tempera paint was pre-packaged rather than freshly mixed. Perhaps Armstrong felt that the works relating to the battle series lent themselves more to oil. Certainly, in *Gaslight*, Armstrong expertly exploits the potential of oil. The slight glean to the surface of the painting evokes a rainy, dark evening in the city. The shoes of the men are reflected on the damp surfaces of the streets, whilst the gas lamps glow with a blue tinge, picking out water on the umbrellas and the pavement. A disconcerting atmosphere is heightened by the supremely unsettling composition – disjointed buildings are decorated with inexplicably placed gaslights whilst a central street lamp dissects the canvas. The alienation of man in a strange city was also explored by René Magritte in works such as *Golconda*, 1953; Menil Collection [fig. 12]. The gentlemen of *Gaslight* seem to be caught in an endless cycle of tramping, relentlessly and endlessly, around the street lamp, caught in a never-ending merry-go-round.

Gaslight 1952

Signed in full and dated lower right
Oil on canvas
40.6 × 35.6 cm / 16 × 14⅛ in

Provenance

Private Collection

Literature

A. Lambirth, A. Armstrong and J. Gibbs, *John Armstrong: The Paintings* (London, 2009), cat. no. 446, colour illustration p. 150.

Exhibitions

1975 London, Royal Academy, John Armstrong 1893-1973 (100)

1984 London, New Grafton Gallery, Barnes, John Armstrong (10)

Fig. 12. René Magritte, *Golconda*, 1953; Menil Collection

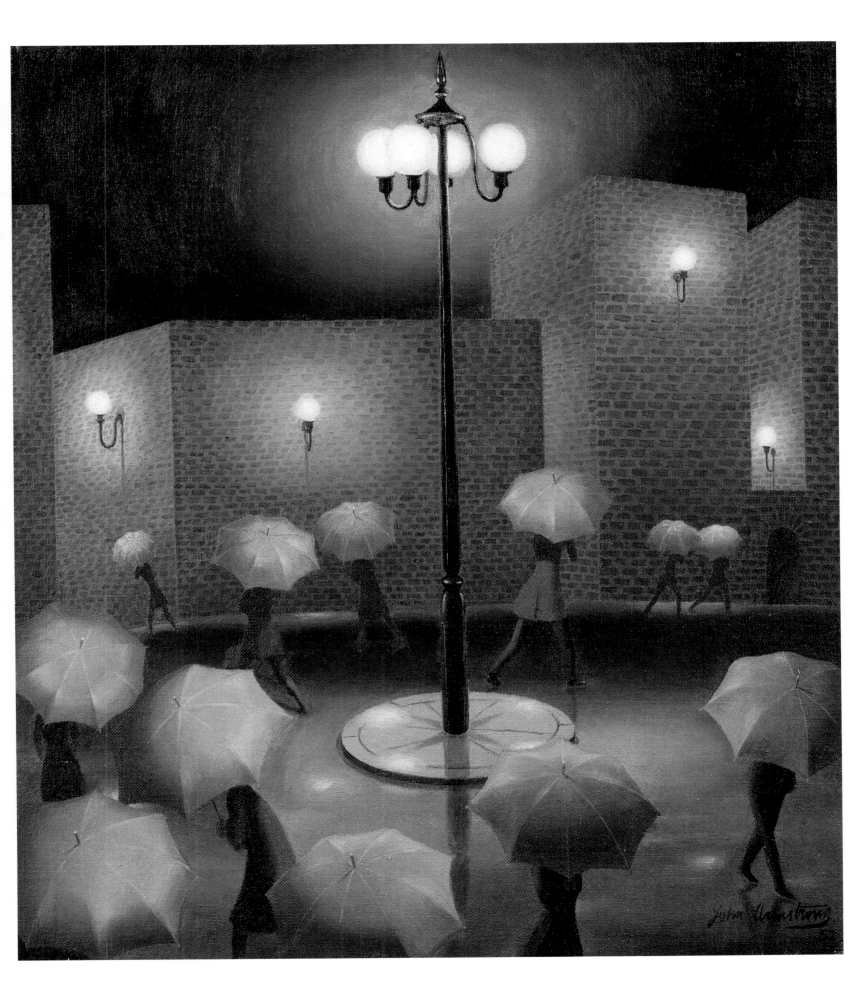

15 FLIGHT 1952

Painted in the same year as *Gaslight* [cat. 14], *Flight* is also part of the series of umbrella-carrying, top-hat wearing metropolitan gentlemen, but takes on a particularly lyrical, romantic tone. Whilst in *Gaslight* the umbrellas become barriers to human interaction, here the umbrellas become tools of escape: a gentleman dressed in Victorian attire and a clown-like man seem about to lift up into flight, borne aloft by their open umbrellas. Rather than being trapped within the towering walls of a city, these men are in a beautiful English countryside of rolling hills - with more than a touch of West Dean Park, his childhood playground, or the Wittenham Clumps - woods, drifting white clouds and deep blue skies. Perhaps they have just touched down in this bucolic idyll, landing in front of a pile of golden straw.

Again Armstrong's handling of oil is exquisitely detailed, picking out gleaming golden straw, the sheen on shoes, highlights on the white ruff of the clown. *Flight* seems as a wistful daydream, a light-hearted, playful fantasy about escaping the monotony of every-day existence through magical flight. In his use of the umbrella as a symbol of fairy tale enchantment and the desire to escape from the confinements of mundane urban life, Armstrong strongly evokes the children's novel, *Mary Poppins*, 1934, by P.L. Travers. Turning to the world of children's stories or folklore and mythology, Armstrong was continuing in a well-established Surrealist tradition of rejecting rational Western adult experience for those with a marginalised perspective.

The gentleman facing out of the picture is a self-portrait of the artist, heightening the poignancy of the desire to escape, particularly as his marriage to Veronica was struggling by 1952, and his correspondence to friends and Veronica expressed his feelings of entrapment in Lamorna. Armstrong clutches to the back of the clown, who seems to lead him towards the hills in the distance. Perhaps Armstrong, the Edwardian gentleman, feels he needs to regain the clear perception of the timeless fool in order to truly understand his present situation.

Flight 1952

Signed in full and dated lower right
Oil on canvas
30.5 × 20.3 cm / 12⅛ × 8 in

Provenance

Private Collection

Literature

A. Lambirth, A. Armstrong and J. Gibbs, *John Armstrong: The Paintings* (London, 2009), cat. no. 450.

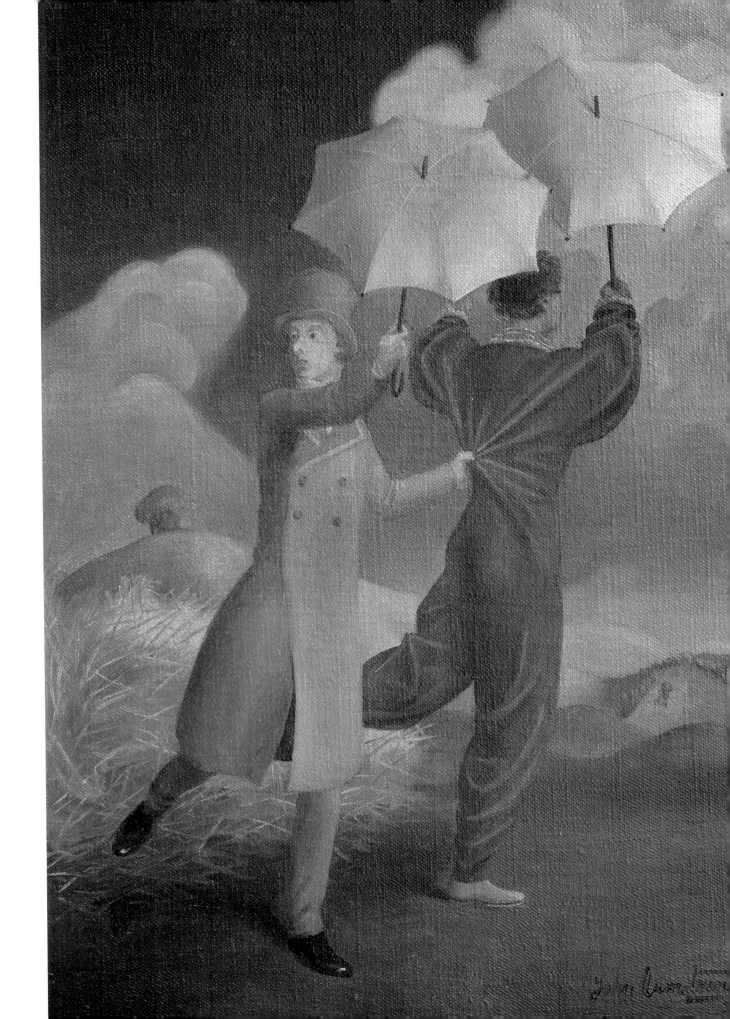

16 THE VISION OF ST TERESA 1953

In 1953 Armstrong returned to the subject of St Teresa of Ávila, the sixteenth-century Spanish nun famed for her writings on her visions and experiences. He painted a group of four similar paintings, depicting St Teresa, eyes closed in rapturous imagining, supported by three nuns. Behind the nuns, a chapel rises up dramatically to meet a huge, glowing moon that rests above a mountain range. In this painting, the larger version of the study now in the Ingram Collection [fig. 13], a brick arch divides the nuns from the romantic, magical background.

The serene mystery of Armstrong's imagery disguises the physicality imbued in his painting, befitting a portrayal of St Teresa. In a passage of writing for the Whitechapel Gallery's 1950 exhibition, *Painters Progress: Lives and Work of Some Living British Painters*, Armstrong described how painting constitutes pattern, "magic, ritual, the crystallization of religion", and form, "the representation of a solid object in an imagined space, springing from the sexual instinct. The first is mental, the second bodily."[33] Understood through the lens of Armstrong's foundation in the magic, ritual, and desire of Freudian-inspired Surrealism, the painting is spiritual rather than religious. *The Vision of St Teresa* is a continuation of a modern British legacy of a mystical and romantic tradition, of the pre-Raphaelites, Aubrey Beardsley, Eric Gill, and into the post-war era such artists as Graham Sutherland and Cecil Collins. The pervasive atmosphere of clandestine secrecy, inexplicable happenings and romantic spiritualism situates *The Vision of St Teresa* within this heritage.

The Vision of St Teresa 1953

Oil on canvas
61 × 50.8 cm / 24⅛ × 20 in

Provenance

Private Collection

Literature

A. Lambirth, A. Armstrong and J. Gibbs, *John Armstrong: The Paintings* (London, 2009), cat. no. 464.

Exhibitions

1977 Colchester, The Minories, John Armstrong Paintings 1935-1970 (19)

1977 King's Lynn, Fermoy Art Gallery, John Armstrong Paintings (32)

1989 London, Mundy & Philo, John Armstrong (19)

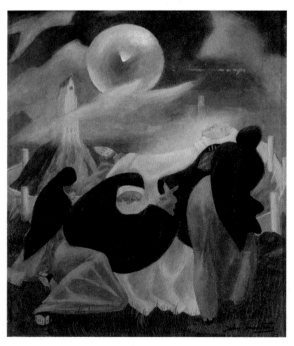

Fig. 13, *The Vision of St Teresa*, 1953; The Ingram Collection of Modern and Contemporary British Art

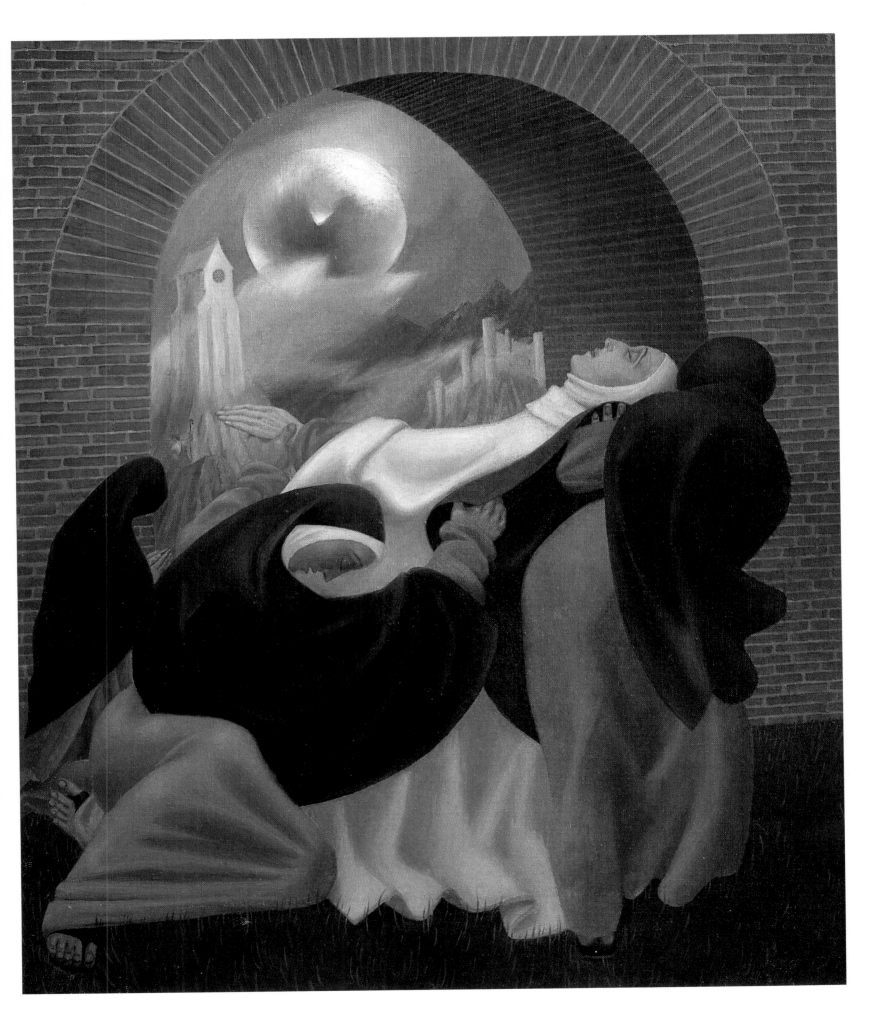

17 THORN AND SEED 1958

Armstrong remained in Lamorna until 1955, when he returned to London upon the breakdown of his marriage. His move back to London, initially staying with his first wife, Benita, precipitated a period of great personal happiness. In 1956 he met his future wife Annette Heaton, thirty-four years his junior, and by 1958 they were expecting their first child, a daughter born in 1959.

Armstrong painted a series of four works called *Thorn and Seed*, full of symbolism of this time of great hope, renewed energy, and possibility. *Thorn and Seed*, 1958, a painting that has only recently resurfaced and is the pair to *Thorn and Seed III*, 1958, is heavy with symbolism of copulation and fecundity – the very title alludes to the potential for new life through nurturing a seed to grow into a tree. A truncated tree, with blue and red bark, stands in an empty field, angular branches spreading across the composition. The two aggressively sharp points of giant, phallic thorns puncture an orb of white seed heads, whilst another cluster of dandelion-like seeds floats next to the tree. This explosion of new life, of potential for growth and propagation, is in stark contrast to the dying tree, with its bark peeling away in the process of decay. A transference of energy and life forces is in process.

The delicacy of the otherworldly colouring and the tender handling of tactile matte oil paint belie the vigorously modernist composition. In the top left corner an interweaving web of smaller branches is cropped by the edge of the composition, and Armstrong plays with the perspective of the thorns, severely receding and projecting from the branches. Like his contemporary Graham Sutherland and building on the precedence of early British Surrealists such as Paul Nash and Edward Wadsworth who were so influenced by the frame of the photograph, Armstrong takes recognisable elements from nature and makes them surreal – distorting scale and viewpoint, cropping disjointedly, and viewing them from unusual perspectives.

Thorn and Seed 1958

Signed 'John Armstrong 1958' lower right
Oil on board
34.5 × 47 cm / 13⅝ × 18½ in

Provenance

Jack Beddington (purchased 1958), and thence by descent Carol Lobb

Private Collection

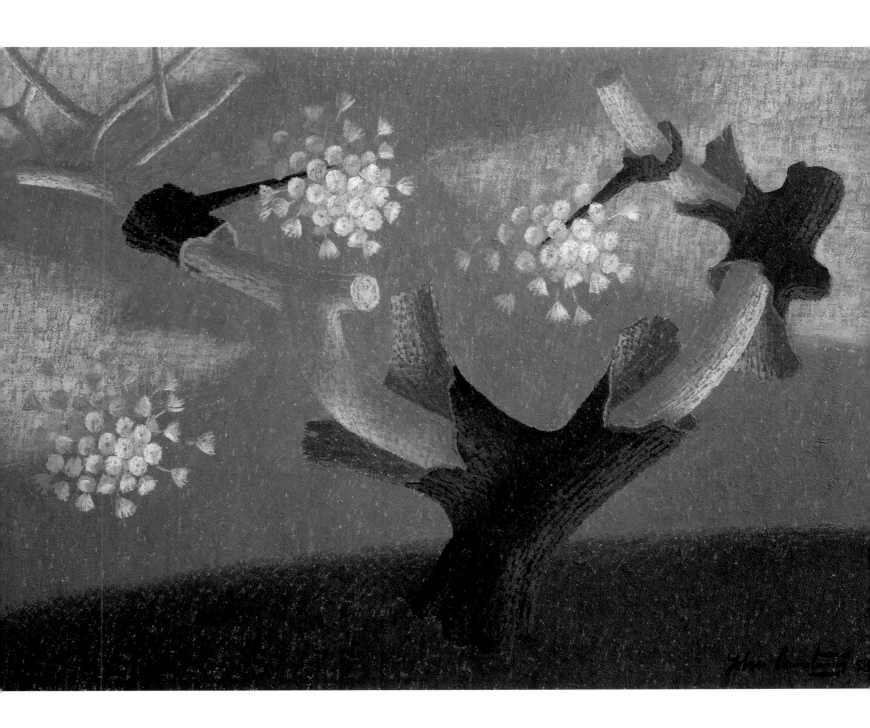

18 THORN AND SEED I 1958

The next work in the *Thorn and Seed* series, *Thorn and Seed I* is one of a pair with *Thorn and Seed II*, constituting the two portrait oriented trees of the grouping. As opposed to the lyricism with a jagged edge of *Thorn and Seed*, *Thorn and Seed I* is a more angst-ridden work – the frame of the painting constricts the tree, which appears about to burst the confines of the picture plane. The thorns sharpened to a dangerous point are more evident in this work, with only one erupting into an explosion of white seeds. The stylised foreshortening of the thorn closest to the foreground evokes the foreshortening in Paolo Uccello's *The Battle of San Romano*, illustrating Armstrong's continued references to this Renaissance master throughout his career, as seen in earlier paintings *The Iceberg* [cat. 8] and *The Battle of Nothing* [cat. 13].

An absolute master craftsman with technique, Armstrong frequently echoed subject matter through his methods, delighting in the sublime surrealism of, for example, painting architecture through touches of paint mimicking brickwork. The additional detail of the broken fence to the lower right of the painting is a mysterious touch. Is this a punctum to catch our attention or is it further, elusive symbolism included by Armstrong? Certainly as well as possessing personal symbolism for Armstrong's present situation with a new marriage and the imminent arrival of his daughter, the work encompasses certain religious connotations such as the crown of thorns.

Whereas with *Thorn and Seed* the orbs of seed heads are redolent of life springing forth, here the tree itself seems to be coming to life, with branches bending and straining, as if caught in active growth. Even the paint seems to be vital – the matte quality of the paint creates a beautifully appealing texture to the surface of the canvas, imitating the bark of the trunk in its grain-like application. Armstrong delights in the juxtaposition between the dark, decaying bark and the light delicacy of the life-carrying seeds.

Thorn and Seed I 1958

Signed in full and dated lower right
Oil on board
35.6 × 30.5 / 14 × 12 in

Provenance

Private Collection

Literature

A. Lambirth, A. Armstrong and J. Gibbs, *John Armstrong: The Paintings*, (London, 2009), cat. no. 639, colour illustration p. 217.

Exhibitions

1977 London, The New Art Centre, John Armstrong (9)

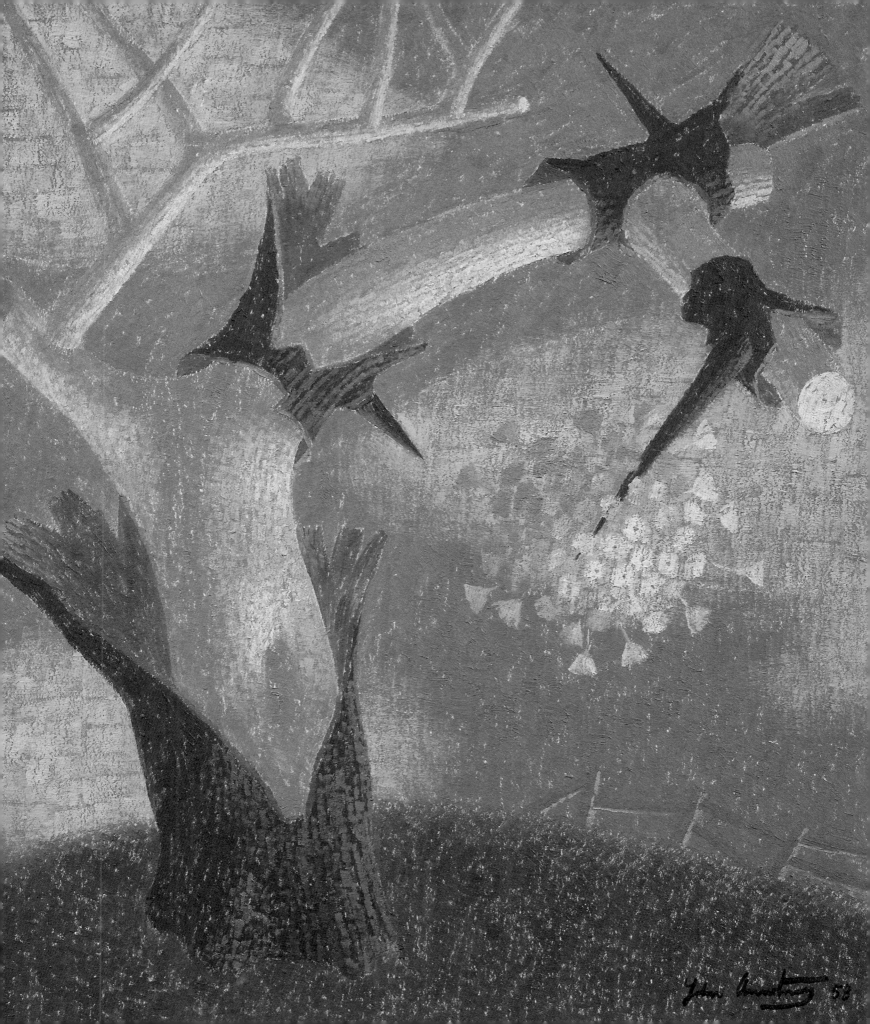

19 VICTORY 1958

Painted in the same year as *Thorn and Seed* [cat. 17] and *Thorn and Seed I* [cat. 18], *Victory* is their antithesis – rather than the hope in new life fostered by *Thorn and Seed*, *Victory* makes palpably evident Armstrong's all-encompassing fear for humanity headed towards imminent death and destruction. Alongside *Victory*, there are only two further works on this subject - a small preparatory work, *Study for Victory*, and *Victory*, the large-scale painting Armstrong exhibited at the Royal Academy of Arts Summer Exhibition in 1958 and which is now in the Royal Academy's Collection. Armstrong was elected an Associate of the Royal Academy in 1966, and a Senior Associate two years later. The *Victory* series is undoubtedly the masterpiece of this mature phase of Armstrong's career, a raw and brutal vision of humanity at its most base. At the Royal Academy Summer Exhibition in 1958, Armstrong explained, "the central figure is a parody of a human being - half-human scarecrow. He's the winner of a nuclear war. The crumpled lumps at either side – they're the losers...".[34] *Victory* is a prophetic history painting, a violently modernist satire of the genre.

Armstrong was not alone in his portentous vision of the Cold War era – the so-called 'Geometry of Fear' sculptors, including Lynn Chadwick, Bernard Meadows and Eduardo Paolozzi, headed by his Unit One colleague Henry Moore, were featured in the infamous 1952 British Pavilion at the Venice Biennale. Herbert Read, the championing critic of Unit One, coined the phrase in the catalogue for the show: "These new images belong to the iconography of despair, or of defiance; and the more innocent the artist, the more effectively he transmits the collective guilt...the geometry of fear".[35]

The composition of *Victory* is dominated by the figure of a demonic scarecrow lurching towards us, with his arms upraised in horror or caricatured victorious celebration. The scarecrow, character of beloved children's tale *The Wonderful Wizard of Oz*, becomes the haunting protagonist of a nightmare. With manically glowing eyes, and a disintegrating body, he is terrifyingly suspended between life and death, yet potently threatening.

Even in this veritable crucifixion scene, however, there is the suggestion of hope through the knowledge that Christ was raised from the dead. Such optimism is perhaps difficult to fathom in such a prophecy of horror, desperation and annihilation, but it is this very paradox of life and death, hope and fear between which Armstrong was torn in 1958. Whilst joyfully anticipating the imminent birth of his daughter in *Thorn and Seed* and *Thorn and Seed I*, he was nonetheless fearful of the world she could inherit. In an undated poem, *Prayer to the Earth*, Armstrong simultaneously expresses fear of death and hope in birth:

Pity our distress
Who feel the winter's breath in thy decline.
Save us from death, for power of life is thine.
We are thy children. Earth, thine is our blood!
Send us thy strength that we may ride the flood
Of our misgivings and our feebleness.
Our hope of life is hourly less and less.
Give us thy fruits, refresh us with thy rain;
Grant us our prayer; That we be born again.[36]

Victory 1958

Signed in full and dated lower left
Oil on board
38.1 × 50.8 cm/ 15 × 20 in

Provenance

Private Collection

Literature

A. Lambirth, A. Armstrong and J. Gibbs, *John Armstrong: The Paintings* (London, 2009), cat. no. 622.

Exhibitions

1963 London, Molton & Lords, John Armstrong (12)

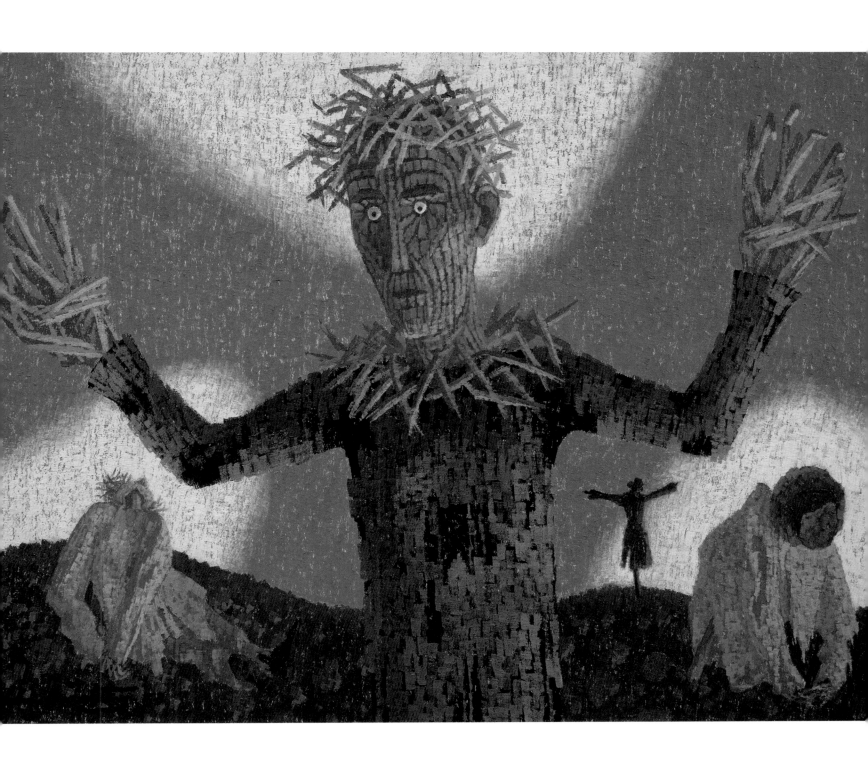

NOTES

1 *Yorkshire Post*, 1 December 1938.

2 'John Armstrong "Charts a Fresh Tract of Dream"' in *Sketch* (vol. CLXXXIV, no. 2393, 7 December 1938), p. 473; *Edinburgh Evening News*, 29 November 1938.

3 'Painter of Dreams in Two Minds', *News Chronicle*, 2 December, 1938.

4 'John Armstrong Goes Surrealist', *Manchester Guardian*, 2 December 1938.

5 'New Paintings by John Armstrong', *Sunday Times*, 4 December 1938; 'A Show of Imaginative Pictures', *The Scotsman*, 5 December 1938.

6 T. W. Earp, 'Foreword' in *Paintings by John Armstrong* (exh. cat., Alex Reid and Lefevre Ltd, London, 1938).

7 Earp.

8 P. Nash, letter to the Editor of *The Times*, 1933, quoted in H. Read, 'Introduction' in H. Read (ed.), *Unit One: The Modern Movement in English Architecture, Painting and Sculpture* (London, Toronto, Melbourne and Sydney, 1934), p. 10.

9 H. Read, 'Introduction' in H. Read (ed.), *Surrealism* (London, 1936), p. 26.

10 J. Armstrong in H. Read (ed.), *Unit One: The Modern Movement in English Architecture, Painting and Sculpture* (London, Toronto, Melbourne and Sydney, 1934), p. 39.

11 I. Coster, 'Half-asleep Painter' in *Evening Standard*, 29 November 1938; *Evening Standard*, 28 November 1938; *Daily Sketch*, 30 November 1938 – "Actually these strange images occur to the artist most mornings in bed during that pleasant half-asleep period which precedes fully waking up."

12 J. Armstrong, private correspondence to Mr. Green, 24 June 1953.

13 Coster.

14 J. Armstrong, 'Painter's Purpose' in *The Studio* (vol. 155, no. 778, Jan-June 1958), p. 76.

15 Armstrong, 'Painter's Purpose', p. 76; A. Breton, 'Manifesto of Surrealism' in *Manifestoes of Surrealism* (trans. R. Seaver and H. R. Lane, Michigan and Don Mills, 1969), p. 26.

16 A. Lambirth, A. Armstrong and J. Gibbs, *John Armstrong: The Paintings* (London, 2009), p. 105.

17 M. Remy, *Surrealism in Britain* (Hants and Vermont, 1999), p. 21.

18 *Reynolds News*, 15 July 1945; *The Times*, 24 July 1945; *New Statesman and Nation*, 21 July 1945; *Studio*, October 1945.

19 J. Armstrong, Tate Archive, TGA 200713/2/17-34.

20 J. Armstrong, private correspondence to Mr. Green, 24 July 1953.

21 J. Armstrong, in H. Read (ed.), *Unit One: The Modern Movement in English Architecture, Painting and Sculpture* (London, Toronto, Melbourne and Sydney, 1934), p. 39.

22 J. Armstrong, unpublished writing, undated.

23 H. Moore in J. Hedgecoe (ed.), *Henry Spencer Moore*, (London and New York 1968), p. 61.

24 P. Nash, in H. Read (ed.), *Unit One: The Modern Movement in English Architecture, Painting and Sculpture* (London, Toronto, Melbourne and Sydney, 1934), p. 80.

25 I. Colquhoun, *Stones of Cornwall* (London, 1957), p. 46.

26 Colquhoun, p. 30.

27 D. W. Thompson, *On Growth and Form* (ed. J. Tyler Bonner, Cambridge, London, New York and Melbourne, 1961), p. 7.

28 J. Armstrong, 'A Note on the Symbols Employed' in *New Paintings by John Armstrong* (exh. cat., The Lefevre Gallery, London, November 1951).

29 J. Armstrong, 'A Thought on Sodom' in *New Statesman*, 15 April 1950.

30 Armstrong, 'A Thought on Sodom'.

31 Armstrong, 'A Note on the Symbols Employed'.

32 M. Ernst, 'Inspiration to Order' in *Max Ernst: Beyond Painting and Other Writings by the Artist and his Friends* (New York, 1948), p. 21.

33 J. Armstrong, 'Written for retrospective show, Whitechapel Art Gallery', unpublished writing, 1950.

34 Lambirth, p. 136.

35 H. Read, 'New Aspects of British Sculpture' in *The XXVI Venice Biennale, The British Pavilion* (exh. cat., London, 1952).

36 J. Armstrong, *Prayer to the Earth*, Tate Archive, TGA 200712/2/1-16.

CHRONOLOGY

1893	Born in Hastings, Sussex
1895	Moves to The Vicarage, West Dean, Chichester
1907-12	St Paul's School, London
1912-13	St John's College, Oxford
1913-14	St John's Wood School of Art
1914-18	Serves during the war with the Royal Field Artillery in Egypt and Macedonia
1924	Elsa Lanchester opens the first Cave of Harmony for which Armstrong decorated the interior. Armstrong paints murals for friends and as major commissions throughout the 1920s and 1930s, including for Samuel and Lillian Courtuald, George Russell Strauss, Labour MP for Lambeth, and Shell-Mex House, The Strand
1926	Creates designs, later published, for theatre production by Sir Nigel Playfair & AP Herbert *Riverside Nights*, a significant introduction into their social circle
1928	Solo exhibition at Leicester Galleries
1929	Solo exhibition at Leicester Galleries
1931	Production of *Façade* at Cambridge Theatre, London, composed by William Walton, choreographed by Frederick Ashton and designed by Armstrong
1932	Armstrong meets Benita Jaeger, best friend of Elsa Lanchester, and later to be his first wife
1934	Unit One exhibition at Mayor Gallery Costume and set designer for Alexander Korda's *The Scarlet Pimpernel*
1935-39	Head of Costume at Denham Studios for Korda films including *Things to Come* and *The Thief of Bagdad*
1938	Solo exhibition at Lefevre Gallery; splits with Benita
1939	Meets his second wife, Veronica Sibthorp, former lover of Dylan Thomas, and moves with her to Tilty, Essex
1940-44	War artist, based on the Home Front
1945	Moves to Lamorna, Cornwall with Veronica Solo exhibition at Lefevre Gallery
1947	Solo exhibition at Lefevre Gallery
1950	Group exhibition, *Painters Progress* at the Whitechapel Art Gallery
1951	Group exhibition, *60 Paintings for '51*, Festival of Britain: works included Telecinema mural and the painting *Storm* One-man exhibition, Lefevre Gallery
1953-55	Paints mural for the Council Chamber, Bristol Council House
1953	Group exhibition, *Figures in a Setting*, Contemporary Art Society Final film design for *Hobsons Choice*, featuring Charles Laughton
1956	Group exhibition, *The Seasons*, Contemporary Art Society
1955	Leaves Lamorna upon breakdown of marriage to Veronica and returns to London
1956	Meets Annette Heaton, his third wife and mother of his daughter, Catherine
1957	Solo exhibition at Leicester Galleries
1958	Group exhibition, *The Religious Theme*, Contemporary Art Society
1961-63	Mural for Royal Marsden Hospital, Sutton, Surrey
1962	Diagnosed with Parkinson's Disease
1963	Solo exhibition, Molton and Lords Gallery, London
1964	Solo exhibition, Shell-Mex House
1965	Group exhibition, *Art in Britain 1930-40*, Marlborough Fine Art
1966	Elected A.R.A.
1973	Dies, London
1975	Memorial exhibition at London, Royal Academy of Arts and Arts Council; and on tour to City Museum and Art Gallery, Plymouth; Harris Museum and Art Gallery, Preston; Laing Art Gallery, Newcastle upon Tyne
1977	Solo exhibitions at Fermoy Gallery, King's Lynn; The Minories, Colchester; The New Art Centre, London
1984	Solo exhibition, New Grafton Gallery, Barnes
1989	Solo exhibition, Mundy and Philo, London
2014-15	Features prominently in exhibition at Pallant House Gallery, Chichester, *Conscience and Conflict: British Artists and the Spanish Civil War*
2015	Solo exhibition, John Armstrong: Paintings 1938-1958; An Enchanted Distance, Piano Nobile, London

SELECTED BIBLIOGRAPHY

Armstrong, J., 'A Note on the Symbols Employed' in *New Paintings by John Armstrong* (exh. cat., The Lefevre Gallery, London, November 1951).

Armstrong, J., 'A Thought on Sodom', in *New Statesman*, 15 April 1950.

Armstrong, J., 'My Paintings and Their Frames', in *The Studio* (vol. 117, Jan-June 1939), pp. 142-145.

Armstrong, J, 'Painter's Purpose' in *The Studio* (vol. 155, no. 778, Jan-June 1958), p. 76.

Colquhoun, I., *Stones of Cornwall* (London, 1957).

Glazebrook, M., *John Armstrong 1893-1973* (exh. cat., Royal Academy of Arts, London 1975).

Lambirth, A., Armstrong, A., and Gibbs, J., *John Armstrong: The Paintings* (London, 2009).

Remy, M., *Surrealism in Britain* (Hants and Vermont, 1999).

(ed.) Read, H., *Unit One: The Modern Movement in English Architecture, Painting and Sculpture* (London, Toronto, Melbourne and Sydney, 1934).

Robertston, A., Remy, M., Gooding, M., and Friedman, T., *Surrealism in Britain in the Thirties* (Leeds, 1986).

Rothenstein, J., *Modern English Painters, Volume Two: Nash to Bawden*, (3rd ed., London and Sydney, 1984).

INDEX

ACKNOWLEDGEMENTS

Piano Nobile wishes to extend its sincere gratitude to
all those who have helped facilitate this exhibition:

David Advani

Jamie Anderson, Waterhouse & Dodd, London

Annette Armstrong

Catherine Armstrong

Richard and Marlin Armstrong

Bridgeman Images

Bristol Museum and Art Gallery

The British Library

The Ingram Collection of Modern and Contemporary British Art

Mrs Ann Cooke

Jonathan and Tara Gibbs

Roger and Caroline Hillier

Imperial War Museum, London

Andrew and Sarah Lambirth

Robert Mapstone

Simon Martin, Pallant House Gallery, Chichester

St Matthew's Church, Northampton

Menil Collection

The Henry Moore Foundation

Peter and Renate Nahum

The National Art Library

National Gallery, London

Newport Museum and Art Gallery

Michael and Julia Pruskin

Stuart and Jenny Sanderson

Tate, London

York Museum Trust

Cat. 1, *The Goddess*, c.1937 (detail)

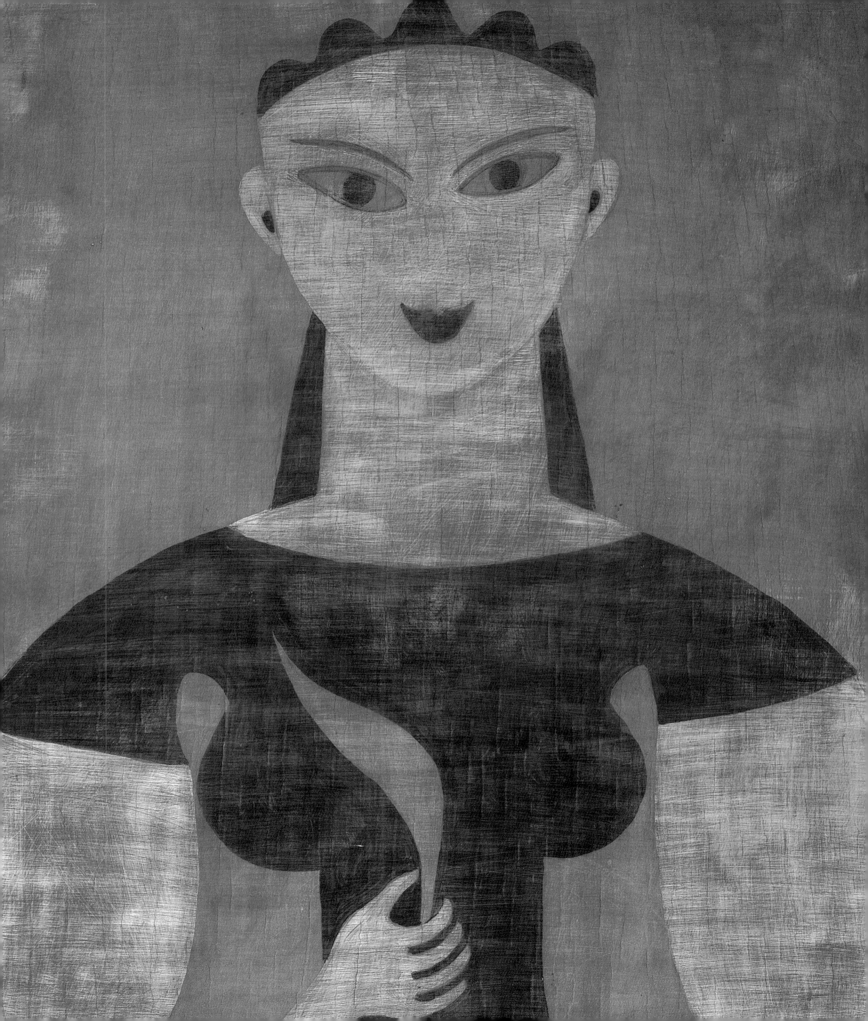

First published to accompany the exhibition

JOHN ARMSTRONG
PAINTINGS 1938–1958

AN ENCHANTED DISTANCE

21 October – 28 November 2015

© Piano Nobile Publications No. XXXIX 2015
ISBN: 978-1-901192-39-1

Research and Text
Julia Fischel

Design
Graham Rees Design

Print and Binding
Deckers Snoeck

Photography
Colin Mills

Index
Elizabeth Wiggans

Distributed by Casemate Group
10 Hythe Bridge Street, Oxford, OX1 2EW
casemategroup.com

Piano Nobile specialises in 20th-century works including International, Modern British and Post-War art. The gallery holds an extensive but selected stock, and also represents an exclusive stable of contemporary artists and artists' estates. Established in 1985, the gallery acts as agents and principals for private, corporate and museum collections dealing with appraisals, acquisitions and dispersals. With a discerning curatorial vision and a reputation for authoritative exhibitions and publications, the gallery seeks the best quality works of art from established and emerging markets.

Front Cover:
Cat. 10, Leaf Forms 1947 (detail)

Back Cover:
Cat. 11, The Jockey 1947

Page 4:
John Armstrong, By Baron,
Conduit Street, London, 1938

Frontispiece:
Cat. 8, Figure in Contemplation 1945 (detail)

PIANO NOBILE | ROBERT TRAVERS WORKS OF ART LTD
129 Portland Road | London W11 4LW | T +44 (0)20 7229 1099
info@piano-nobile.com | piano-nobile.com